DRAWING by SEEING

John Torreano
DRAWING by SEEING

ABRAMS STUDIO
ABRAMS, NEW YORK

For Laurence King
Designer: MARC&ANNA
Photo Research: Cecilia Mackay

For Abrams
Cover Design: Sarah Gifford

Library of Congress Cataloging-in-Publication Data
Torreano, John.
 Drawing by seeing / John Torreano.
 p. cm.
 Includes index.
 ISBN-13: 978-0-8109-9170-5 (pbk.)
 ISBN-10: 0-8109-9170-5
 1. Drawing—Study and teaching. 2. Perception. I. Title.

 NC593.T67 2007
 741.2—dc22
 2006103156

First published in 2007 by Laurence King Publishing Ltd., London
Published in North America in 2007 by Abrams, an imprint of Harry N. Abrams, Inc.

Printed and bound in China
10 9 8 7 6 5 4 3 2 1

HNA
harry n. abrams, inc.
a subsidiary of La Martinière Groupe

115 West 18th Street
New York, NY 10011
www.hnabooks.com

Contents

Introduction

This book is meant for those who want to increase their ability to translate seen images from the three dimensional world to the two-dimensional plane of a drawing on paper. Though personal expression has an important role in drawing, the emphasis here is more on the means than the ends. However, that said, my experience has led me to believe that one's ability to be expressive with drawing is in direct proportion to one's increased ability to "see." There is a synergistic relationship: the more you learn to "see," the freer you are to draw with authority and expressiveness.

What do we mean by the ability to "see" in the context of drawing? Ask yourself this question: "Why can't I draw what I see? After all, I have been using my eyes all my life to make complicated, detailed, and accurate decisions when driving the car, sewing, fixing things, playing games such as billiards, and so on. But when I try to draw an image with a pencil on a piece of paper it comes out clumsy and distorted." The simple answer is, "You can't draw what you see because you can't 'see' what you are looking at in terms of two dimensions."

Normally our seeing process is integrated with all the other senses plus memory, experience, and knowledge. For example, when we look at a chair for the functional purpose of sitting down we only need enough visual information to identify it as a "chair" in the general sense. A very small amount of information is necessary to determine whether you can sit down on it. However, when we look at the same chair for the purpose of drawing we must "see" it solely as a set of particular visual cues (shapes) presented to us at that moment. No two people observing the same chair at the same time will be "seeing" the same set of cues. In this book we will explore the concepts of *customary perception* and *aesthetic perception*. Customary perception of the chair is general and has the same three-dimensional meaning or function for everyone, while aesthetic perception of that same chair is specific and refers to the particular two-dimensional shapes unique to each person's viewpoint at a given moment. Thus drawing can

be one of the most direct and economic ways to give expression to one's unique perceptions.

In order to "draw by seeing" we must, in a sense, distort the use of our eyes in that we isolate "seeing" from its normally integrated customary function. Most art forms do this to varying degrees. For example, a singer trains her voice and vocal cords to hit notes not normally required for speaking or an actor trains himself to be able to experience particular emotional moments on stage or in front of a camera. The visual artist must train his or her eyes to see three-dimensional things as two-dimensional shapes in order to draw them on a flat piece of paper and have them appear to be three-dimensional.

The basic premise of this book is that customary perception (drawing what you "know") is in conflict with aesthetic perception (drawing what you "see"). The exercises that follow are designed to physically and mentally make this conflict become conscious. With the "making a first drawing" exercise, you will learn how customary perception causes unintentional distortions by analyzing the kinesthetic clichés that happen unintentionally. Embedded in our very musculature, they are the natural result of a customary response to the aesthetic task of drawing. In addition you will be introduced to a language, borrowed from Gestalt perceptual psychology, that is specific to the two-dimensional visual characteristics of drawing. Each of the six exercises that follow—line constancy, the cloud exercise, making marks, the baroque exercise, landscape, and the grid self-portrait—focuses on the problem of "seeing" in a different way. However, all of them are designed to reinforce the same essential principle that it is better to consider the drawing as a whole than to become too embroiled in the detail of each area. The result will be a more unified drawing. Over the years I have tested and refined these exercises with a wide variety of students, young and older, with varying degrees of experience, and have had great success. Positive results can happen quickly if you maintain your focus on the specifics of each exercise as you do it.

Origins of the idea

Although you may find it easier to understand the principles behind these exercises if you work through them sequentially, you can also think of them as similar to recipes in a cookbook and try any of the exercises that appeal to you at a given moment. Each exercise is designed to unravel problem areas caused by customary perception and, at the same time, offer new techniques that reveal how aesthetic perception contributes to your drawing possibilities.

One might ask, "Why, in this age of ever-increasing technical means, is drawing a viable enterprise? Is it important to draw, by hand, so to speak?" As a professor in the Department of Art and Arts Professions at New York University for the past fifteen years I continue to be impressed by the number of students who take our Introduction to Drawing classes. Typically, they come from other areas within the university, from business and law to literature, drama, and so on. I believe there is a hunger for an educational experience that is not academic or "in the head," but rather one more personal, physical, and "in the body." The act of drawing is a balance of intimate and personal expression with a public, observable result. There is something wonderful in being able to translate a multidimensional perception to a flat, two-dimensional piece of paper. It requires prioritizing one's choices and making complex decisions at a kinesthetic level. The process is uniquely individual as it involves the very musculature of each person's body. When drawing, we are simultaneously "thinking" with both our bodies and our minds.

Drawing is also the most direct and economic way to express ideas. It could be said that we already use some form of drawing in our daily lives—even the act of writing can be considered a form of drawing. After all, most writing forms originated from "pictographic" sequences—think of hieroglyphics. With help I believe anyone can learn to draw with increased freedom and authority. There is a lot to be gained by exercising this kind of knowledge.

The title *Drawing by Seeing* is borrowed from a book written by Hoyt L. Sherman published in 1948. My first introduction to Mr. Sherman's work took place while I was an undergraduate student at the Cranbrook Academy of Art from 1961–63. A fellow student friend of mine, Michael Torlen, had returned from winter break with a book, also authored by Mr. Sherman, entitled *Cézanne and Visual Form*. This book was an elaborate analysis of Cézanne's painting from a Gestalt perceptual perspective. To me, the language and its formalist underpinnings were both mysterious and exciting. I was not acquainted with any such training or language applied to art. This was exciting to me for it offered a pedagogical approach to the visual arts. The language was consistent and specific and applied to anyone's work, regardless of whether it was abstract or figurative. A number of my fellow students and I pursued these ideas in a series of lively group discussions, which led to our making a trip from Michigan to Ohio State University for an interview with Mr. Sherman. Both Michael Torlen and I attended OSU for graduate school in order to study with Mr. Sherman and his colleague Robert King. (Michael is on the faculty and a founding member of the Visual Arts Program at Purchase College, State University of New York.)

Mr. Sherman's book, *Drawing by Seeing*, has been out of print for over fifty years. In it he describes an experiment made during World War II, around 1942–43. At the time, there was a need to help US Air Force pilots make correct, spontaneous decisions in the confusion of battle: they were shooting down as many American planes as enemy ones (today this would be called "friendly fire"). Airmen were trained to memorize pictures of all the different airplanes in use, friend and foe, in a part-to-part fashion. As I understand it, Mr. Sherman received money from the US government to test his Gestalt approach to seeing and drawing as a way to "increase general perceptual acuity" while working with students selected from the armed forces. Although the book does not refer to this source of support, I thought it interesting to mention the context of the study the book describes.

The book serves as a description of the experiment, its premises and conclusions. The premise was that an increase in one's ability to see the whole *Gestalt* would also increase one's ability to make more accurate spontaneous decisions in the moment. The book contains illustrations of the "flash-lab," the drawing studio where the experiment took place. This was an entirely lightproof room, so that all of the drawing took place in the dark. Specially designed slides, made by Mr. Sherman himself, were projected onto a screen for $\frac{1}{100}$ of a second. It was his contention that it is impossible to see part-to-part (seeing an object in terms of its parts, rather than the whole) at that rate of speed. After responding to the flash from one of these slides, the students would draw in total darkness. In such an environment an afterimage will last several seconds. This after-image was, in effect, what the students were drawing from. The first projected images were very simple abstract shapes that dealt with location and size and progressed in complexity to include overlap, brightness differences, figurative images, etc.

As a Master of Fine Arts (MFA) student I was awarded a teaching assistantship, which afforded me the opportunity to teach one course per term of Introduction to Drawing. I was allowed to reinstitute the use of the original flash-lab to aid in the teaching of our beginning students. Thus I was able to experiment with the language and approach of Mr. Sherman and Mr. King.

Early on I realized that it was possible, using the flash-lab, to cause students to make very competent, even exciting, drawings within a very short period of time—two weeks. However, when they returned to a normal drawing environment, they would revert back to their beginning drawing levels. They were unable to utilize those perceptual experiences as repeatable skills. It became apparent to me that a cognitive parallel to the Gestalt experiences was necessary.

Since those early days I have experimented with drawing classes to develop a synthesis of the experiential with the cognitive. This has proved to be very effective. I believe this book can help teachers, students, and others to realize insights and skills from drawing that will stay with them forever.

Making a first drawing

We use our eyes to make precise visual decisions every day. We can navigate a car through traffic, clean the house, sew a hem, and repair a torn piece of paper. But when we try to draw something with a pencil on a piece of paper, it doesn't look anything like the object or view we see in front of us. It looks awkward. Things are distorted or too flat, and so on. This doesn't make any sense. What happens when we try to draw?

As an experiment make a drawing. Think of this first drawing as a personal test sample, in the same spirit that a voice teacher might ask you to sing a song in your first meeting. Pick something you would like to be able to draw. It doesn't have to be complicated or ambitious. We will use this drawing to analyze what happens when you try to draw. Perhaps you could draw something familiar such as a chair. You could do a portrait of a friend, or try drawing your pet. What you choose to draw is up to you.

Try this!
MAKING A FIRST DRAWING

You will need a piece of drawing paper at least 12 x 14 in. (30 x 36 cm) in size, and your choice of pencil (medium to soft) or charcoal (soft vine, not compressed). If you are drawing a friend, the pose should be simple and relaxed. For the sake of your model and the purposes of this test drawing, try to limit yourself to 15 or 20 minutes. Set an alarm if you have one and check the time periodically. When your time is up, stop drawing even if the drawing is incomplete, or you feel it isn't "right." Our point here is to examine the results, not to judge the results. Sign and date the drawing in the lower right-hand corner and hang it on the wall.

Stand back and examine your drawing. It is not uncommon to have a negative response to these first drawings—you might not even want to hang them on the wall. However, early on, you should try to overcome the impulse to judge your drawings. Don't think of them as "good" or "bad." Try, instead, to look at them as sources of information. Learn to be a bit distant and analytical. Our purpose for these first drawings is to help illustrate the effect **customary perception** (see page 14) has on the process of drawing.

Questions to ask

- Were you able to "complete" the drawing in the time allotted?

- Were you able to keep the whole image on the page or did you find, at the end of the allotted time, there wasn't enough room for the head or the feet?

- Did you use line on the edge of all your shapes?

- Did you start with your line at the top and move toward the bottom proceeding from **part to part**?

- Does the line you drew look **hairy**? This characteristic is the result of having made a series of repetitive short strokes on the edge of your shapes.

- Does the drawing seem **distorted**? If you drew a chair, do the legs look too long or too short? Did you show more of the seat of the chair than you were able to see?

This is not a bad drawing of a chair. However, it is not the chair the student actually saw.

The student has drawn more of the seat than was actually seen.

The legs are too short.

The points of intersection are overemphasized.

The points of intersection are overemphasized.

The student has drawn more of the seat than was actually seen.

The legs are too short.

Right-handed cliché— diagonal lines.

- If you drew the figure, did you have to cripple the legs to make them fit on the page?

- If you drew a friend, is the head too big or too little for the body? Do creases in the face make your friend look like an old man when she is, in fact, a young woman?

- Were you able to include details such as the hands, feet, eyes, ears, mouth, etc.? Or did you leave those areas unattended, because they seemed "too hard"?

- Is there an obvious diagonal right- or left-handed stroke to your lines?

- Did you overemphasize **points of intersection**? This is the result of pressing down harder with your pencil or charcoal at visually illogical points. With a chair it might occur where the leg of the chair joins the seat. With a figure it typically happens under the chin, in the crook of the neck, at the wrists, inside the elbows, in the crotch, etc.

These symptoms are common to everyone who has had difficulty with drawing. They are all the result of trying to solve the problem of drawing on the two-dimensional plane of a piece of paper with the same logic you would use to make everyday visual decisions in a three-dimensional world. Thus the simple answer to the question "Why can't I draw what I see?" is: You can't draw what you see because you can't "see" in two dimensions, the terms required for drawing.

This drawing exemplifies the "hairy line" cliché, caused by making a series of repetitive short strokes.

The points of intersection—the crotch, and the top of the hip—are over-emphasized.

The feet have been left unattended and lack any defining detail.

This drawing demonstrates a reasonably smooth motion in its execution. However, there is unintentional distortion in the elongated nearest back leg, and the seat is tipped up.

These hairy lines cause the viewer to see the edges more prominently than the shapes. The interior spaces of the shapes feel like voids.

The emphasized point of intersection comes forward, visually canceling any possible overlap of the shapes.

Points of intersection are overemphasized—they come forward visually, while the front edge of the seat recedes. This is a good example of contradictory brightness.

The shapes in this drawing are distorted—more of the seat is shown than was seen.

The student has not assessed the scale of the drawing and, drawing from top to bottom, has consequently run out of paper.

Learning to see

In order to "draw by seeing" we must alter the way we use our eyes so that we can isolate "seeing" from its everyday function. For our purpose, we refer to this kind of everyday seeing—seeing what you know—as **customary perception**. For example, when we identify a chair for the purpose of sitting down, we use only a small amount of visual information to make that decision. We simply need to "know" that it is a chair, in a general sense. Customary perception is purposeful: everyone in the room will see the same chair in terms of its general purpose, as an object on which to sit. The chair represents the same three-dimensional function to everyone.

However, when we put our chair up on a platform in order to draw it, we must learn how to "see" this three-dimensional object differently. We now need to see it as a set of two-dimensional shapes (cues) that we can draw on a flat piece of paper so that they will look three-dimensional. We refer to this kind of "seeing" as **aesthetic perception**—seeing the three-dimensional world in terms of the two-dimensional space of drawing. An aesthetic perception of that same chair will be unique and specific to each person. No two people observing it will "see" the same set of cues at the same time. Each person will have a visually specific configuration according to that person's unique point of view in that room.

A process based on customary perception, or drawing what you "know," is in conflict with aesthetic perception, drawing what you actually "see." We do not, initially, know how to look at objects two-dimensionally. Therefore we rely on customary perception to help guide our drawing. We respond, not to the particular visual cues being presented to us from the chair, but to our internal generalized concept of the object known as "chair." We know it has a seat, a back, and four legs. We cannot, as yet, look at the chair for what it is to "see" in this pure sense, therefore we try to draw the three-dimensional version we "know." The result is that we create **unintentional distortions**. For example, we may show

more of the seat than we actually see. We might draw all four legs of the chair even if, from our particular vantage point, we can see only two or three. This distortion is the reason our version of the chair looks primitive or childlike.

Almost all unintentional distortions in our drawings result from the conflict between customary and aesthetic perception. However, inexperienced people do not feel the same degree of frustration when asked to make a sculptural version of something in three dimensions. For example, I once gave each student in my Introduction to Drawing class a piece of clay and asked them to make a

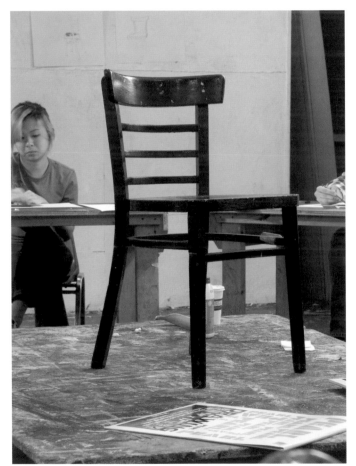

sculpture based on an object I put on the model stand. Everyone was able to do that without hesitation. But when I asked them to do a drawing from their clay version of the object all the same frustrations returned. The fact that it was something they had made themselves made no difference when it came to the problem of drawing an image of it on a piece of paper.

This contradiction can be easily explained. The sculpting process takes place within three-dimensional space. Consequently, the students were able to make a one-to-one relationship between the object/model and their piece of clay. In this case customary perception would help them. However, when they were asked to do a drawing of their three-dimensional versions of the object, they had to see the object as a two-dimensional abstraction from a single point of view. In other words, creating the object in three dimensions didn't actually help them to draw an image of it in two dimensions.

The student is showing more of the seat and more of the fourth leg than he has actually seen. He has executed the drawing according to his customary perception, based on the purpose of the chair rather than what he can actually see.

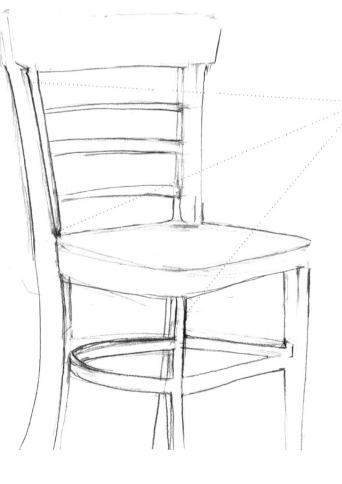

Illogical use of brightness confuses the overall order of the drawing.

Drawing from the top of the page to the bottom without assessing the scale, the student has run out of paper.

Imaginary, tactile drawing

In addition to confusing what we know with what we see, we may also have a distorted sense of space: we continue to think in three dimensions. This causes us to view the piece of paper as a spatial void into which we will place our version of the chair. We start by imagining that the chair is sitting in the space that is the page in front of us. We then imagine ourselves literally drawing around it, by touching its surfaces with our pencils or charcoal. This is a tactile response to a visual problem. By "feeling" the chair in this way, we believe we will be able to recreate its image within the paper's void. However, as we continue to try to sculpt it on this flat plane, we make incredible distortions. For it is impossible to sculpt a three-dimensional object on a two-dimensional plane.

This **imaginary tactile response** is another way of trying to use customary perception. It is why we will try to draw parts we "know" exist, in our *imagined* three-dimensional space, even if we do not actually "see" them.

Kinesthetic clichés

An imaginary tactile response is the reason we make the **kinesthetic clichés** we will encounter and try to overcome through the exercises in this book. Good examples of these clichés are: to make irregular or "hairy" lines, inappropriate overemphasis of points of intersection and contradictory depth cues.

These kinesthetic clichés are the symptoms of an unconscious, customary response to the aesthetic problem of drawing. Throughout our lives, our bodies develop physically embedded behavior from the simple act of walking or running to more complex skills such as skiing, playing billiards, etc. All of these physical skills become unconscious and feel natural. They become part of the body's knowledge. I call this kinesthetic knowledge. When we first attempt to draw we will, unconsciously, try to touch the flat paper in the same way we would move and touch the three-dimensional object itself. This feels natural to us. But, as we have seen, trying to do this causes us to make unintended distortions in our drawings. In order to overcome this we must retrain ourselves. It may feel unnatural at first but, gradually, as we begin to understand the causes behind these symptoms, we will begin to develop a new physical knowledge, a kinesthetic aesthetic, which is more appropriate to the needs of drawing.

Contradictory depth cues

A good example of a common symptom of an imaginary tactile response is the **contradictory depth cue**. This occurs in our work when we push down harder with our pencils in an effort literally to "reach" the deeper areas of the space, and pull back with a lighter touch in the areas closer to us. By attempting to reach into flat space as if it were three-dimensional, we inadvertently create visually contradictory cues for **depth perception** (the illusion of depth in a two-dimensional work).

The contrast between bright areas and lighter areas is one of the main ways in which depth is conveyed: what is brighter will appear to be closer. I call this the brightness cue for depth. By pressing down harder with the pencil or charcoal, we make those lines and marks darker. By emphasizing them in this way, we unwittingly make them "read" as "brighter" and thus visually closer to the viewer. Conversely the lighter, softer, less contrasting areas appear farther from the viewer. When using contrast to enhance a sense of depth, the brightest areas should, ideally, lie on the parts of the subject that are closer. This means drawing with a light touch in areas that are farther away and pressing down harder in closer areas.

The reason we make these visual contradictions comes from the tendency to see the flat paper as a void of imagined space. We literally try to reach into that space with our pencils and in the process inadvertently press down harder, causing the deeper areas to appear brighter.

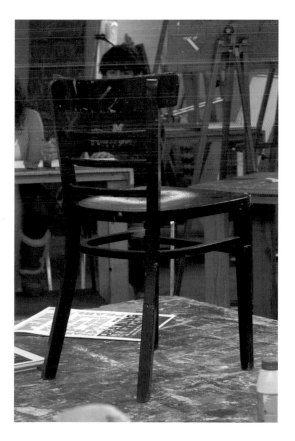

Note the unintentional distortions in this drawing. The artist cannot accept the amount of the seat he can actually see and so tips it up to show more of what he "knows" is there.

The student "knows" the chair has four legs so has drawn them all, even though he can see only three in their entirety.

In making the back legs of the chair light and the front legs dark, by attempting to "reach" for them, he has created a visual contradiction.

Look at the drawing of two sets of railroad tracks and try to reproduce them using a piece of drawing paper, 12 x 14 in (30 x 36 cm), and a piece of charcoal or a pencil.

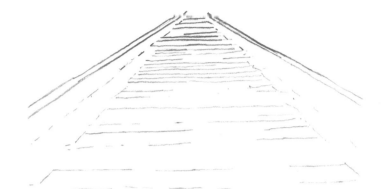

I FROM LIGHT TO HEAVY
First draw a set of railroad tracks similar to the one on the right. Start from the front, which would be the visually closest point of the tracks, and push into the space, toward the vanishing point, where the lines converge. This will cause the farthest point to be the "brightest."

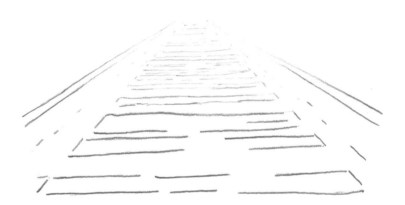

2 FROM HEAVY TO LIGHT
Now draw another set of tracks using the opposite pressure. Again, start from the front but this time begin with intense pressure using gradually lighter and lighter pressure toward the distance. This will cause the closest point to be the "brightest."

You will experience a physical conflict. This is the kinesthetic contradiction I have described. In the first drawing it will feel natural to push into the space (with the pencil or charcoal) in an attempt to reach the distant point. It feels natural, but the effort to "reach in" results in putting extra pressure on the charcoal which, in turn, causes those deeper areas to become brighter and therefore to appear visually closer. In the second drawing it doesn't feel right to press down hard in the closer areas and lightly in the deeper areas, but the illusion of depth is more effective in the finished drawing.

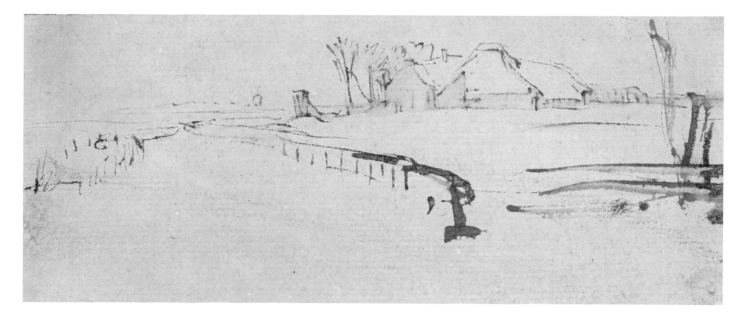

Rembrandt Harmenszoon van Rijn, *Landscape with a Farmstead* (Winter Landscape), c. 1648–50. Brown ink and brown wash on cream antique laid paper.
Fogg Art Museum, Bequest of Charles A. Loeser, 1932.368 (photo: Photographic Services).

Rembrandt has created an illusion of depth in this drawing by using precisely the method described on page 18: creating darker, therefore "brighter" marks in the foreground. This high contrast appears visually closer than the fainter, low-contrast elements in the distance.

Points of intersection

Another reason we make **contradictory brightness cues** is by unconsciously overemphasizing points of intersection—another kinesthetic cliché. For example, when drawing a figure, we might press down harder with our pencil or charcoal to emphasize actual physical intersections such as at the wrists, the elbows, and the knees. It also occurs at places that are part of the imaginary touching process, which aren't related to physiology, such as under the chin or the breasts, where we might perceive a slight shadow and unconsciously reach in to touch the area. In the case of an object such as a chair, it could happen where the leg or back connects to the seat. Being emphasized, these points appear closer to the viewer.

There are explanations for why we do this. When we focus our attention on a particular part of an object we become more aware of it, to the exclusion of the rest of the object (as well as the rest of the drawing). Therefore, a point of intersection will appear darker to us because of a perceived shadow. So we make it as dark as we see it, at that moment. When we adjust our point of view and pay attention to the whole object, we realize that this point is no darker than the rest. However, it is very difficult, in the beginning, for us to make these visual adjustments from a specific point of our focus to the general view. We tend to look from part to part, focusing on one point before going to the next. With practice it will eventually become second nature to shift back and forth between seeing the whole object and concentrating on a particular detail. Until we are made aware of these exaggerations, we will continue to press down much harder at these points of intersection, out of proportion to the overall view.

Another reason we tend to overemphasize is that we place greater value on these details. When drawing a human figure, for example, we equate the model's points of intersection with our own joints, our own elbows, wrists, knees, and ankles, and thus see them as more vital than the spaces between them. Yet if we were to look at the body as a whole, these intersections do not stand out *visually*. We just feel that they do. It is somewhat the same with objects. We see the structural points of intersection, such as where the legs of a chair connect to the seat, as more important than the spaces between. For customary functional purposes they are more vital. However, visually, they are usually the same.

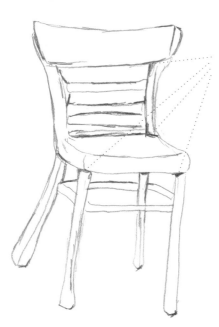

The student has overemphasized the points of intersection. These are of structural importance but should not be given particular visual emphasis.

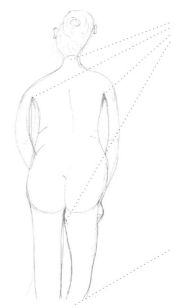

The points of intersection—the neck, the armpits, and the crotch—are overemphasized.

No room has been left for the feet—a result of drawing from top to bottom.

Part-to-part ordering

Look back at the drawings from the exercise on pages 11–13. They were probably drawn with an outline, usually starting at the top and working downward. Unconsciously you might have felt, "If I can complete this part correctly then I can go on to the next." However, as the image becomes more complete, you may have discovered that it doesn't "look right" or you ran out of room for the head or the feet.

The process of moving from one part to the next is referred to as **part-to-part ordering**. It is another manifestation of customary perception. Our inclination is to draw according to a sequential order we understand, focusing on the individual elements that, in three-dimensional reality, make up the whole. As an example, consider a vase of flowers on a table. A customary response would be to draw this still life by proceeding in the order we know it was put together as a collection of separate objects. We might begin by drawing the table first, then adding the tablecloth, next the vase, and finally the flowers.

This sequencing makes sense to us within an imagined three-dimensional space. The order is based on imitating the physical process required to arrange the still life in real time—it is not based on how we actually "see" the image. For the purpose of drawing, it would be more appropriate to look at the still life as a collection of visually different shapes, created by the objects that are simultaneously present.

Another good example of the use of part-to-part ordering is in the drawing of a tree. An inexperienced person might use a sequence based on how he or she thinks a tree grows—first the trunk, then the branches coming out of the trunk, and finally the leaves attached to the branches, in effect growing it from one part to the next. Sometimes we apply this same sequence logic to the figure. First we draw the torso then we attach the arms, legs, and the head. (Very often we leave the head off completely or save it for later due to a fear that we will ruin the face.)

By drawing from part-to-part—concentrating on one area before moving on to another—we will inevitably end up with a drawing that does not feel unified. This happens because we are not able to see the different ways we treat each separate part. Part-to-part ordering is another manifestation of customary perception that we will overcome as we master drawing by seeing.

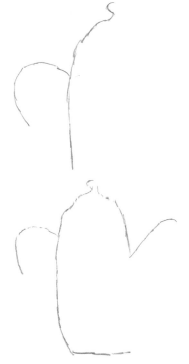

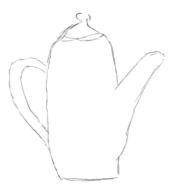

This sequence of drawings of a pitcher demonstrates a typical part-to-part ordering. The process begins at the top and proceeds down the sides until the object is "captured." This imagined tactile response does not allow the marking process to indicate possible visual cues such as location, size, shape, character, etc., that could aid in the drawing.

Hierarchical valuing of parts

The sequential decisions we make when drawing can be based on a **hierarchical valuing** we have attached to the parts. Let's take figure drawing as an example. In normal life experience, we pay more attention to a person's head. When we are speaking to someone we look at and address our words to their face: we do not normally look at their entire body. This is one explanation why, in a full figure drawing, we typically start with the head—a small shape compared to the whole figure—and then proceed to the torso, which is a larger shape. Using drawing logic, trying to attach a large shape such as a torso to the smaller shape of the head is like trying to screw the ketchup bottle into the cap instead of screwing the cap onto the bottle. Alternatively, we might move downward from the head to the neck, shoulders, arms, or torso until we get lost and confused. Very quickly we discover that we are at the bottom of the page without enough space for the legs and feet.

With practice we can learn to "see" what we are drawing, rather than make assumptions about what an object looks like based on what we "think." The exercises in this book will help you make the shift from customary perception to aesthetic perception by revealing why we make distortions when we draw. As you become more aware, you will naturally retrain your thought processes and movements and begin to make decisions that are more appropriate to drawing.

Line constancy

- Learn how to focus on the whole page, rather than working from part to part.

- Begin to focus on the act of drawing on the flat paper, rather than making an imaginary drawing around the three-dimensional object.

- Learn how to use the two-dimensional depth cues of position, size, brightness, and overlap, and avoid overemphasizing points of intersection.

In spite of the old adage, "there are no lines in nature," the most common characteristic of all first drawings—and all drawings in general, for that matter—is the use of line. It is precisely because making a line is the first response we have to drawing that the first exercise in this chapter involves line. For this exercise you will draw shapes using only line, no shading, and no "filling in." The goal here is to maintain **line constancy**. This means you will try not to have any variation in intensity (darks and lights) within the line itself. So, when the drawing is completed, all the lines should have a consistent degree of intensity.

When we first begin to draw, we tend to focus on the contact point of the pencil on the paper, as if being correct at that point is critical (see part-to-part ordering on page 21). But in learning to maintain line constancy you will become aware of how hard you are pressing down on the paper with your pencil or charcoal at any one time, and by trying to avoid pressing down harder in one area than another, your attention will leave that one particular point and you will then be able to begin to think about the drawing as a whole. You will become less **object-oriented** and become more **drawing-oriented**. As you proceed, the question to ask is, "Do I need to lighten the touch here or press down harder there in order to maintain an equal intensity across the drawing?" The act of making these kinds of choices may be your first formal experience of drawing by seeing.

It may take several drawings before you are successful at controlling the intensity of the line. You may think you are maintaining control, but our customary response to any object is embedded in our musculature, unconsciously and kinesthetically. Initially you may not be aware that you are creating subtle irregularities in intensity. That is why it is a good idea to pin your first attempts on the wall and examine them from a distance. It can also be helpful to do these drawings in a group with others: everyone has difficulty maintaining line constancy with his or her first attempts and it makes it easier to understand when you recognize that we all share the same customary perceptual responses to varying degrees. Seeing this inclination as innate makes the problem more obvious to us.

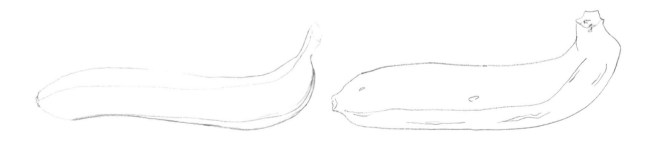

In this drawing of a banana, the line on the front (closest to the viewer) is faint, while the line underneath is darker (brighter). This is the reason the drawing lacks volumetric character.

When the lines are consistent in intensity, as above, the drawing feels more unified and volumetric. The drawing has been executed as a whole, according to how the artist actually sees the banana in reality, the whole thing being simultaneously present.

Try this!
LINE CONSTANCY

You will need a piece of drawing paper 18 x 24 in. (45 x 60 cm), soft pencils, and an eraser. For your subjects, choose simple objects that are self-contained and without a lot of texture or details, such as a cup, a hat, a banana, or an apple. Using simple objects is easier to begin with because you can readily see the edges of the whole shape.

The objects in these photos are generally similar in character therefore accounting for their subtle differences can be a fun challenge. Try drawing from a real pepper first and then see how it feels to draw from a photo of one. When you make marks on the interior of the shape (to define a stem or to put lines for dimples in a squash, for example) be sure to continue to maintain a consistent pressure. Experiment from drawing to drawing by using a very intense line with one drawing and a lighter intensity in another. Just be sure to maintain consistent intensity levels within each drawing.

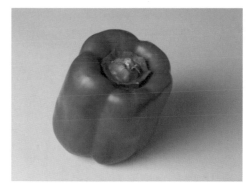

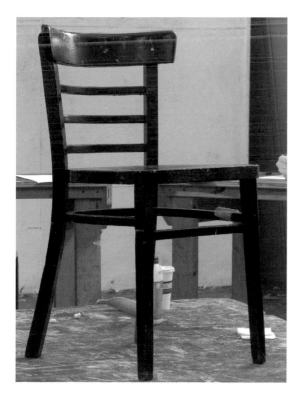

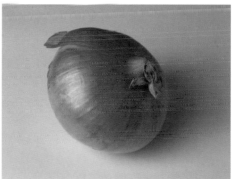

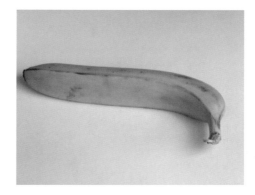

Make a series of drawings of these single objects, maintaining control of the line's intensity for each drawing. Draw one object on each piece of paper. As in our first drawing, try to make the image of the object as large as possible and still fit on the page. Because of the increased scale, you will have to make pressure judgments by looking at areas other than the contact point of your pencil. Also, it forces you to anticipate the image's shape before you draw it. This is similar to "picturing the shot" just before you shoot in games such as billiards or basketball.

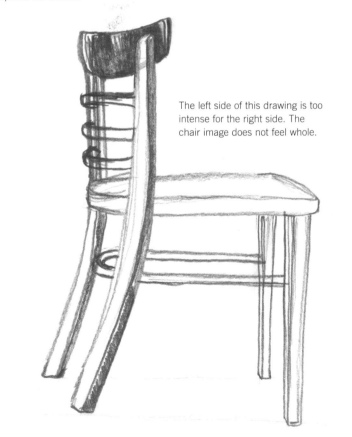

A very sensitive and well-drawn onion image, but it is hurt somewhat by the overemphasized black spot at the bottom.

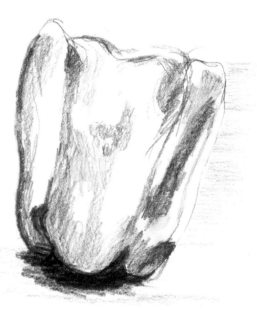

The left side of this drawing is too intense for the right side. The chair image does not feel whole.

Points of intersection are overemphasized, canceling the volumetric character of the pepper. Possible solutions are to even out the contrast either by increasing the intensity of the whole pepper to equal the bottom, or erase the dark areas to equalize them with the rest of the marks.

This drawing of a squash has managed to maintain line constancy, but the hairy-line cliché makes the line so thick and regular that it does not create a sense of volumetric character.

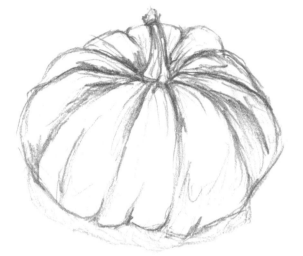

This is a subtle drawing with expressive character of line, and the student was able to convey the difference of size and position of the onion and the pepper. However, those slight differences of intensity at the top and bottom of the shapes keep them from feeling stable.

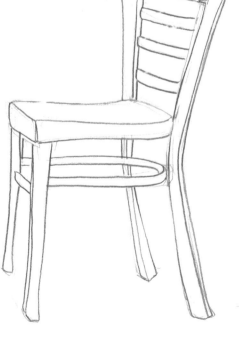

This is a good example of a first attempt. The student was able to make a large image while maintaining line constancy and has achieved some overlap clarity.

Try this!
PRIMARY DEPTH CUES

Once you have mastered line constancy, you can apply your new skill to a series of drawings that will introduce you to the four **primary depth cues**—the visual devices that give a drawing the illusion of three-dimensional depth—**positioning**, **size**, **brightness**, and **overlap**.

1 POSITION

Draw, with line only, the same object in two different positions on the page. Draw one near the top and the other near the bottom. Maintain line constancy and make both drawings the same size. This is a simple exploration of *positioning*. As such, it is not a strong depth cue. However, having the ability to locate a shape where you want it is crucial. Though the images are the same size, the bottom one will appear closer to the viewer (see **Horizontal baseline**, page 30).

2 SIZE

As before, draw an object twice on the same piece of paper, but this time vary the size of the drawings. First make a very large one, then a very small one. This is an exercise in *size differentiation*. Differences in the size of shapes give the illusion of depth, and the largest shape will appear to be closest to the viewer. In customary perception, that which is closer appears visually larger because closer images are larger on the retina.

3 BRIGHTNESS

Draw an object in two different positions on the page and make both drawings the same size. This time, however, vary the intensity of the line from one drawing to the next while still maintaining line constancy within each version. Make the first very intense by pressing down hard with your pencil. Then make a very light version. This is an exercise in *brightness variation*. The most intensely drawn—and therefore seemingly "brightest"—shape will appear to be closest to the viewer. This is because, in customary perception, we see things that are closer to us in greater detail than things in the distance.

4 OVERLAP

When you draw the two objects this time, have them overlap each other. You can vary their sizes, if you like, and be inventive with location, but continue to maintain line constancy throughout the drawing. This drawing is an exercise in *making and defining overlaps*. In this case, the shape that is "in front" of the others—i.e., the one that overlaps most—will appear closest to the viewer, even if it happens to be smaller than the others. Overlap is the most powerful of the four primary depth cues. In customary perception, objects, regardless of their size, overlap in sequence from the closest to you at the front to the farthest away at the back.

With this series of drawings you have experienced how the primary depth cues of position, size, brightness, and overlap function. By controlling line intensity and, at the same time, exploring the depth cues, you have gone from a total dependence on the object/model to making drawing-based judgments. This is a big step. To become drawing-oriented rather than object-oriented adds tremendously to your authority over the page. You now have some skills that inform the drawing process itself, rather than having to rely entirely on an imaginary tactile response to the object (see page 16).

Horizontal baseline

There is a position-based depth cue referred to as the **horizontal baseline cue**. It is not a strong depth cue but supports our understanding of *overlap*. It explains why the sun and the moon look so huge when close to the horizon.

Try this experiment. When the moon is on the horizon look through a piece of paper that has a hole in it. As you look through the hole, adjust it to fit the moon. Later, when the moon has risen from the horizon, do the same thing from the same position. You will see that, while we perceive it as looking smaller, there is no difference in the visual size of the moon. The mind tricks us. We perceive the moon as larger when it is on the horizon because we assume it is closer to us as it is farther down in our vision. To compensate, the mind stimulates a false size cue.

Working with overlap

Of the primary depth cues applicable to drawing, learning how to see and to **define overlap** is the most crucial and therefore requires special attention. A well-defined overlap can create a powerful illusion of volume and depth. And it doesn't matter how distorted the shapes are. Well-defined overlaps can make extremely distorted drawings feel convincing to the viewer. The reason for this is that clearly defined overlapping shapes, even highly distorted ones, will imply volumetric form without the use of shading or modeling. Suddenly a hand, foot, or eye will take on shape character if you attend to the potential overlap possibilities. Of the three depth cues, overlap will often override the effect of the others.

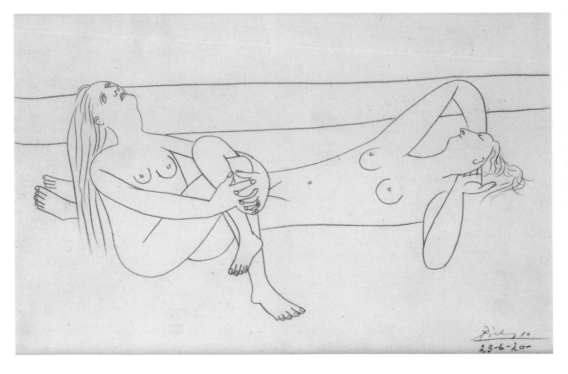

Pablo Picasso, *Two Nudes on a Beach*, 1920. Pencil on paper. Nationalgalerie, Museum Berggruen, Berlin (photo: bpk/ Nationalgalerie, Museum Berggruen, SMB/Jens Ziehe).

Picasso understood the effect of well-defined overlaps. The figures in this drawing are very distorted, intentionally so, but feel convincing nonetheless in terms of their volumetric form. Neither is the clarity of expression compromised—we can read clearly what is what, from the different facial expressions to the clasped hands.

As you become more aware of points of intersection, in an effort not to overemphasize them you may start to resist dealing with potential overlaps altogether. It is better to seek out overlap possibilities and learn how to define them effectively. When working with overlaps, look out for the following:

This student's drawing of an easel is a successful example of well-defined overlaps. Even the small shapes in this drawing are visually accessible.

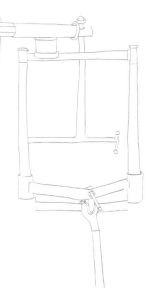

- **Tentative lines:** at points of intersection, your lines do not actually meet and therefore the shapes cannot overlap.

- **Successful overlaps:** these are created when the lines meet without crossing over each other, allowing one shape's edge to yield to another.

- **Lazy lines:** in this case, the lines cross each other, which has the effect of cancelling out the potential for overlap. The lines appear to hang in a spatial void like loose spaghetti.

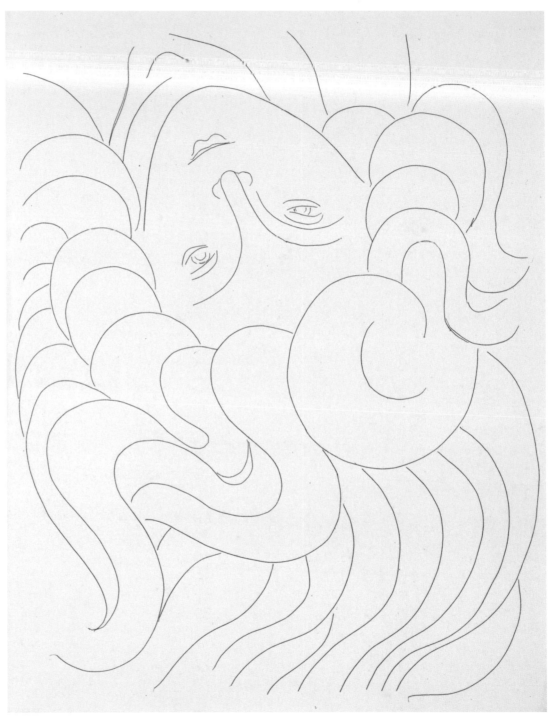

Henri Matisse, *The Mane of Hair,* page from "Poésies," 1932. Etching. Minneapolis Institute of Arts, gift of Bruce B. Dayton. B.81.13.4.

Like Picasso, Matisse was a master at employing overlap. This drawing is a terrific example of how effective the combination of line constancy and clearly defined overlaps can be for giving volumetric character to the shapes.

Perceived overlap

In customary perception, objects closest to us overlap each other in a sequence. For example, when we look at the photo (or the drawing) of students working, the shape of the table closest to us is both larger and lower down than the rest of the shapes. One student's arm overlaps the piece of paper she is drawing on. The paper overlaps the table she is using. Next, that table overlaps the seated student, who in turn overlaps the next table, and so on. As you move up the page, the shapes overlap each other in sequence and simultaneously tend to diminish in size.

Generally, in customary perception, objects that are lower down in our visual **field** appear closer to us. If you were to draw two similar shapes the same size, with one near the top of your drawing paper and the other near the bottom, the one near the bottom will appear closer to the viewer (see Position, page 28). This happens for the same reason the moon looks huge on the horizon. The mind tricks us. Our customary perception assumes that which is lower in our field of vision is closer to us. (See **Horizontal baseline**, page 30.)

From bottom to top:

1. Arm over paper,
2. Paper over table,
3. Table over student,
4. Student over other tables, and so on.

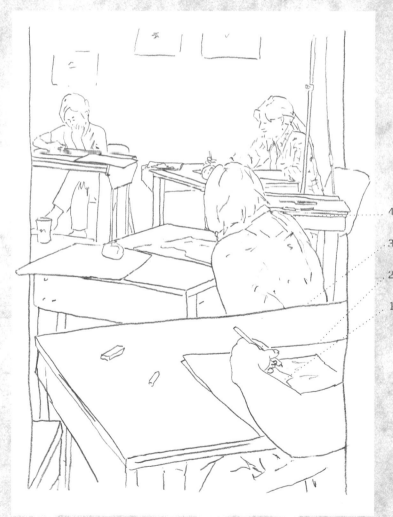

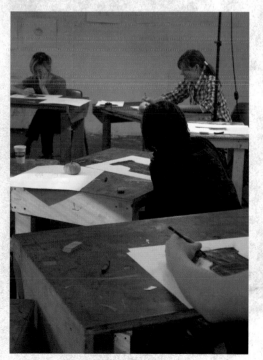

I INTERIOR ARCHITECTURAL DRAWING

You will need a piece of paper 18 x 24 in. (45 x 60 cm),
soft pencils, and an eraser. Do a series of line-constancy
drawings of the architectural details in your room.
Try simple areas at first: the intersection of a pipe with
another pipe, the place where a window is overlapped
by the casing, etc. Every shape you identify in your
room will both overlap and be overlapped by another
shape. Pay particular attention to points of intersection.
By defining your overlaps and not overemphasizing the
intersection of shapes, you will see how volumetric
form can be created without "modeling" the shape
with shading.

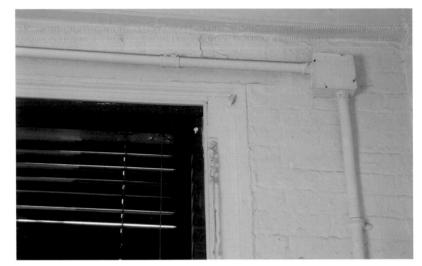

It's a good idea to do these
drawings, as this student has,
by drawing the shapes off of
the page. Doing this helps
make every area of the paper
a potential shape, including
the window, the blinds, and
even the wall.

Note how this student has made
a point of using two horizontal
lines to define the very narrow
spaces between the blinds. He
has also done this with the
vertical strings and support
webbing. This gives a great deal
of clarity to the window shape.

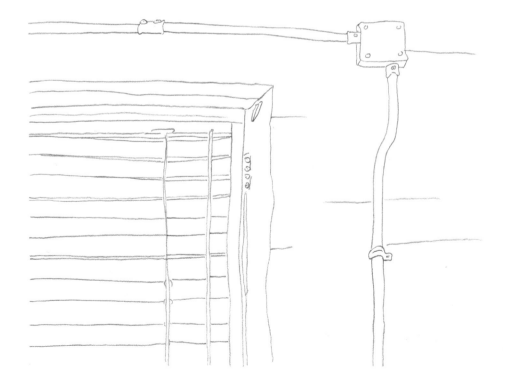

2 REWORKING DRAWINGS TO CLARIFY OVERLAPS

Once you have completed a few interior drawings and become more skilled at finding opportunities for overlap, try reworking one of your earlier drawings. A lot can be gained from this exercise. Take some of your first drawings and see what you can do to improve them. Concentrate on clarifying ill-defined overlaps.

Take one of your most incomplete and distorted drawings and look for potential overlaps. If you are working on a figure, do whatever it takes to complete hands, arms, faces, feet, etc. Be inventive. Make things up. It will, most likely, require that you make extreme distortions in order to connect the parts and define their overlaps. So, stretch those incomplete arms and legs and make them overlap each other (think Picasso). If you are working on an object, try to reposition the seat of the chair, or attach a missing stalk to a pepper. As you rework the drawing, it will go from feeling amateurish and primitive to convincing and expressive. It may end up being highly expressionistic or surrealistic but, nonetheless, it will be more volumetrically and spatially convincing.

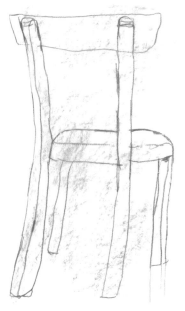

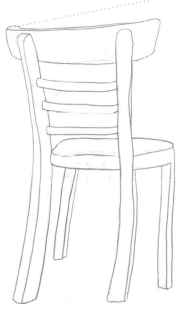

Details like the small shape added to the top of the back rest make a big difference to increasing the volumetric character of the drawing.

This is a good example of an "older attempt." It exhibits a number of symptoms, from inconsistent line usage to ineffective overlaps, but its scale and positioning on the page are quite good. Therefore reworking it is a good idea.

First, try to "open the drawing" by equalizing it. You can do this by rubbing the drawing with your hands and/or erasing the bright spots. The goal is to make everything equal in intensity.

Notice how the student has been able to refresh this drawing. Now the shapes have clearly defined overlaps and increased particularity. Note, for example, the difference between the back-rest area on the original and the new one.

3 ELIMINATING BRIGHT SPOTS

Controlling line intensity will help you to become more aware of the unconscious impulse to overemphasize points of intersection. You will be more sensitive to those "bright spots" and how they create contradictory illusions that can contribute to visual confusion.

With earlier drawings that exhibit such emphasized points, try this experiment. Use your eraser to get rid of the bright spots in order to equalize their intensity with the rest of the lines in the drawing—you'll be surprised at how vigorous you can be. As you erase, you will notice an increase in visual clarity of the overall drawing. When the lines become more equal in intensity, the shapes they form will begin to emerge and appear more volumetric and more whole. You may need to go back in with a pencil to help bring some of the erased lines back to the same level of intensity as the others.

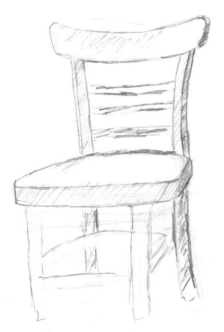

This chair drawing was a first drawing. It has many kinesthetic clichés. There are right-handedness, ill-defined overlaps, overemphasized and inappropriate uses of brightness. It is also incomplete, which makes it a good candidate for reworking!

First, equalize the drawing by erasing all the bright areas. You want to achieve an overall even tone. This prepares the page for new lines and marks. Right away you can see a difference—this erased drawing is more unified than the original.

Now go back in with your pencils and/or charcoal and complete the drawing. The overlaps have been defined and the marks no longer indicate right- or left-handedness.

When reworking charcoal drawings, you can wipe across the drawing with the flat of your hands instead of erasing. Doing this eliminates intensity variation in the line while increasing the visual unity of the drawing. Make use of this wiping action on a regular basis. It is aesthetically effective in that it reaffirms the flatness of the page. This, in turn, subverts the tendency to see your drawn images as objects rather than shapes. When your hand physically experiences the flatness of the page, you are denying the reality of the object in favor of the reality of the flat shape(s), increasing your authority over the page. It also gives you more freedom to make big changes while in the process of making the drawing. To change focus from the object/model to the drawing process itself is a big jump and can be quite empowering. Feel free to go back in with charcoal and/or pencil. Do whatever it takes to rejuvenate and complete the drawing.

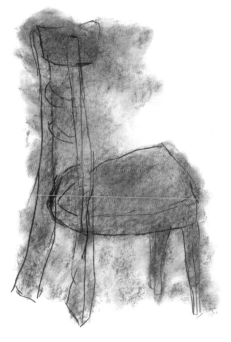

Charcoal was used to make this drawing. It is distorted, with ineffective overlaps and a few inconsistent bright spots.

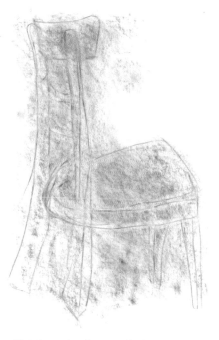

First the student has equalized the drawing by wiping it with the flats of her hands. Next she has erased the bright spots with vigorous erasing. It is now ready for reworking.

Using a consistent line intensity, the student has reshaped the seat to show less of its surface, and has done a great job realizing the potential overlaps. It is still distorted, but has a more convincing three-dimensional and stable quality.

Personal expression

You may feel that enforcing control over the intensity of your lines, as we have been doing with these exercises, stifles your self-expression. You may question the need to control and ask: "Why not let the body respond the way it wants to?" The reason is that the irregular intensities happen because the body is not responding visually. By gaining experience and mastery in creating a line that is based on a visual response, you will gain command over the page and be in control of the effects you want to convey. Your effects won't "just happen." Instead they will become part of your expressive intentions.

Controlling the intensity of the line can actually give you more expressive possibilities by emphasizing the **character** of the lines and the shapes you make with them. Your lines may have a similar personal and distinct character to your handwriting, which is why I sometimes refer to this as a "signature" quality. A good example of this can be seen in the student drawing of a seated model.

Without overemphasizing points of intersection or varying the intensity of line, this student has been very expressive with the character of the lines, and the shapes they form, in his response to this particular model.

Signatures

For fun, try this experiment. You will need a piece of drawing paper 18 x 24 in. (45 x 60 cm), and different tools such as pencil, ink, charcoal, etc. Sign your name on the paper three or four times. Try to vary the sizes of the signatures. Make a big one, then a little one, and then one that is between the other two in size. Examine the results. Most often the intensity within each signature will be consistent. A person's signature does not usually have a variety of intensities in the line and yet it expresses a unique and individual character.

As you become more confident and able to mark freely on the page, you will eventually respond to drawing situations with a similar degree of freedom as signing your name. Your personal kinesthetic character will naturally emerge in your drawings as a result of this spontaneity.

The cloud exercise

- See three-dimensional objects or models and two-dimensional shapes.

- Overcome the tendency to work from part to part and learn how to draw holistically.

- Understand how to make a stable shape.

There are essentially two ways to create a shape on the flat plane of a two dimensional drawing: with an outline that defines the edge of a shape, and with shapes that form their own edges. All drawings in the history of art fall between these two. We explored line constancy in the last chapter and used line to define shape. With the **cloud exercise** we will create shapes from the inside out. Our shapes will define their own edges. Learning to see a general cloud version of the object will aid in our ability to see the object in two dimensions. Drawing a cloud version of the object as a flat shape on the piece of paper in front of us helps teach us how to see in terms of drawing. Seeing and drawing three-dimensional objects in two dimensions is the first stage in learning to draw without making unintentional distortions.

Imagine a continuum with a drawing by Henri Matisse emphasizing line at one end and a drawing by Georges Seurat, which is made entirely with shape, at the other. With these representing the extreme polarities, an ink drawing by Vincent Van Gogh would be a good example for the midpoint along the continuum, as his marks combine to suggest the edges of the shape.

From a few lines to imply shape at one end of the spectrum to many marks at the other end, all drawings fall between these two extremes. From left to right, these marks are in the style of Matisse, Van Gogh, and Seurat.

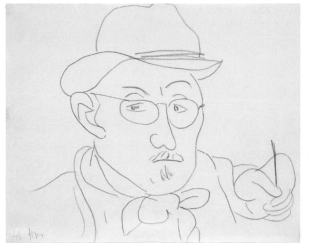

Henri Matisse, *Self-portrait*, 1945.
Pencil on paper. Museum of
Modern Art (MoMA), New York
John S. Newberry Fund.
Acc. n.: 634.1965.

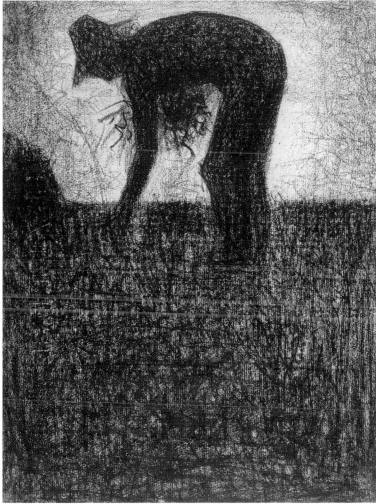

Georges Seurat, *The Gleaner*,
nineteenth century. Conté crayon
drawing. British Museum, London
(The Art Archive / British Museum /
Eileen Tweedy).

Note how the different methods of execution
used by Matisse and Seurat exemplify the
extremes of our spectrum. Matisse's drawing
was done solely with lines that form shapes
and Seurat's drawing was done without lines.
His shapes define their own edges.

This simple cloud exercise serves as an introduction that will help prepare you for the more complex shapes that will follow when we use objects or the figure. Again, it is not so much about making perfect squares but, rather, to gain a sense of the process. For this exercise you will need a piece of paper 18 x 24 in. (45 x 60 cm) in size, and a piece of soft vine charcoal.

This diagram shows how your right-hand square should grow from a dot to a square. Note that at every stage the shape always defines its own edge.

1 USING OUTLINE
First, draw the outline of a square to the left side of your paper (not too big).

2 USING THE CLOUD TECHNIQUE
Now draw another square on the right. Without outlining, start in the general area you think will be the center of your square. Begin with a dot and work out toward the edges—think of it as "growing your dot" toward a square shape, pushing out toward all sides (similar to rolling out a pie crust). Resist the impulse to make a quick outline and then fill in either from the top to bottom or left to right. This impulse comes from our customary perception and implies a part-to-part habit: see page 21. Strive to have your square grow to a similar size as the outlined one. Finally, particularize your nebulous shape as a square by giving it sharply defined edges and corners, from the inside out.

3 MAKING MARKS

When you have completed your black square, in the empty space between the two squares imitate Van Gogh's marks to *imply* a similar-sized square shape. There should be no outlines when you have finished this middle square, just marks that imply the shape.

The outline surrounds the square. The shaped square defines its own edges, and the marked square implies its own edges.

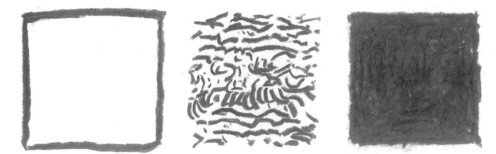

As in our line drawing exercises on pages 10–13, begin with simple objects—a piece of fruit (a banana), a cup, a hat, or a chair. You will need a piece of paper 18 x 24 in. (45 x 60 cm) in size and soft vine charcoal.

I USING THE EMPTY-HANDS TECHNIQUE

Place the charcoal to the right of the paper on your drawing table (left side if you are left-handed). With eyes closed, rub your hands together vigorously and put them on the flat surface of the paper. You should use both hands. Avoid just touching the paper with the tips of your fingers. Instead use the whole flat of the hand. It is important to physically feel the flatness of the page. Rubbing the paper with the flat of your hands will contribute to your internal physical sense of its flatness. This in turn will help you to translate the three-dimensional shapes in front of you into flat, two-dimensional shapes. With your eyes closed you will know, internally, where the paper is on the table. Later, when you are drawing the cloud, you will not have to constantly look back and forth. Small actions such as these help demystify the paper's preciousness by reinforcing the sensation of its physical reality.

2 GROWING THE SHAPE

After a short period of rubbing the page, open your eyes, pick up your charcoal and start forming your shape from the inside out, just as you did when you "grew your dot" to a square. Basically, you will be making a silhouette of the object from your point of view, but instead of outlining and filling in, you will be doing the reverse. Start by pushing from the middle of the shape outward toward its edges. Use lots of pressure with the charcoal. This will again help you to reinforce the flatness of the page. Remember, the process is similar to rolling out a pie crust. Try to avoid moving from top to bottom or from left to right. You may get impatient and want to quickly outline and fill in. When that happens, get back "inside the shape." As your shape grows you can make it more defined by articulating its edge. Learn to value the inside-out process.

The cloud shape for the image of the chair starts right in the center. From the very beginning, you are drawing the whole shape, which is equivalent to how we actually see the chair. We see the chair as a whole thing rather than as a series of part-to-part steps.

Reminders and suggestions

DRAWING THE WHOLE SHAPE

To do this exercise properly you must try to see and draw the whole shape right from the beginning—not the "banana" or the "shoe," per se, but the shape you are "seeing," which should be emerging on your paper. At first it will be very small—nothing more than the shape made by the piece of charcoal you are using. Nevertheless, it still contains, in embryo, as it were, the whole of the image you are drawing. Of course it will be a very general and unspecific shape in the beginning, perhaps nothing more than the difference between a vertical emphasis or a horizontal emphasis.

Each object you draw will have its own unique **shape-of-space**, and this is what you will learn to see and draw in the cloud exercise. When you look at each object or model, imagine what shape that object/model would take up were it a flat shape on the page. Alternatively, try to imagine what size box that shape would need to contain it completely. You are aiming to contain everything in your flat shape, including any spaces inside the shape. There are no separate, identifiable parts, only this one flat shape.

MAKING VARIED MARKS

As you proceed in "growing" your shape by pushing the charcoal in all directions, try for a variety of movements with the charcoal. Ideally you should not be able to identify a particular pattern of marks in your cloud shape.

The reason for varying your marking process is so that your emerging shape is a general equivalent to the one you are seeing. When you make marks using particular patterns such as right to left, top to bottom, or with the right- or left-handed clichés (see page 11), your shape will feel disconnected from the page. It will not feel integrated with the page in the same way as the shape you are seeing is integrated with its background or setting. In addition, identifiable patterns indicate part-to-part ordering and a continued focus on the object (physical) and not the shape (visual).

This banana cloud shape clearly manifests the right-handed cliché. We can see the physical movement from left to right almost more than the banana's shape. This is why the shape appears to "float" in a void.

The multidirectional marking for this banana shape allows the shape to function as a simultaneous equivalent to the existing object. Therefore, it feels more solid and stable. You can see the banana even though there are no details.

Your movements

Notice how much your elbow is moving as you draw. A multiplicity of movements is a good sign. If you draw with your wrist alone, you will only be able to move the pencil in two directions on the page. If you use your elbow, you can move the pencil in many more directions.

Questions to ask

As you draw your cloud shape, stop drawing every few seconds and stand back to get a clear overall view of your paper. Ask yourself these questions:

• Is the shape I now have on the page, at this moment (after a few seconds of drawing), reflecting the object I am looking at?

• Does my shape include everything?

• Am I waiting to finish one part before going on to the next?

• Hold up a **viewfinder** with a rectangular window the same proportion as your piece of paper. Look at the object through this viewfinder and then look at your shape on the page. Do you see a difference in the two shapes? If so, make adjustments to your cloud shape. See if you can, in a general sense, make yours similar to the one you are "seeing." (A suggestion: it may seem old-fashioned, even quaint, but holding your hands up with your two thumbs touching to "make a frame"—a "**hands frame**"—can serve the same purpose as a viewfinder.)

The viewfinder aids in showing you the flatness of your subject. Cropping it in this way makes it easier to see the abstraction and concentrate on the shapes.

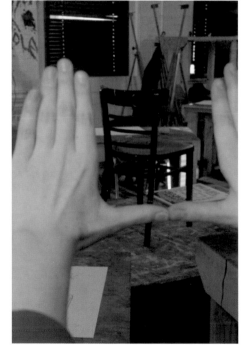

The "hands frame" offers an immediate aid in viewing your subject.

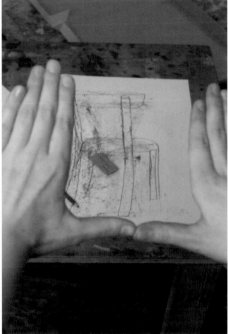

With this "tool" you can look back and forth between your subject and your drawing to see if you are, in fact, drawing what you are seeing.

After you have completed a series of cloud drawings from simple objects you can add line. This serves to clarify your image of the object, which will demonstrate how accurately you were forming the shape with your cloud. Use the same materials as before, but this time you will need a pencil and an eraser, too.

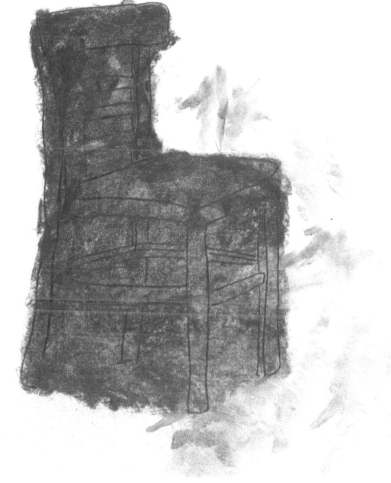

Sometimes you can barely see what you are doing. Trust the cloud to guide you. It is important to stay inside the cloud; otherwise you defeat its role.

3 ADDING LINE TO YOUR CLOUD

Continue to grow your cloud of the chair shape. When you have a good version of the shape you are seeing, pick up your pencil and draw with intense outlines around the object. (Always try to maintain line constancy.) Your cloud shape will be quite dark and messy because of the charcoal and your lines may be difficult to see. You must depend on your cloud shape to guide your lines. It is important that you stay within the boundaries of *your* cloud even if in the process of drawing the lines you discover it is "wrong." (Do not think of the line as something to "correct" along the way. It is only meant to help clarify and define the object within your cloud shape.)

Using the cloud as a guide for the lines should enable you to act quickly and decisively. Start with the outside borders of the shape first, then move to the interior. Include as much as you can. For now you should resist the desire to "shade." As in the line-constancy exercise (see page 25), seek opportunities for overlaps and define them.

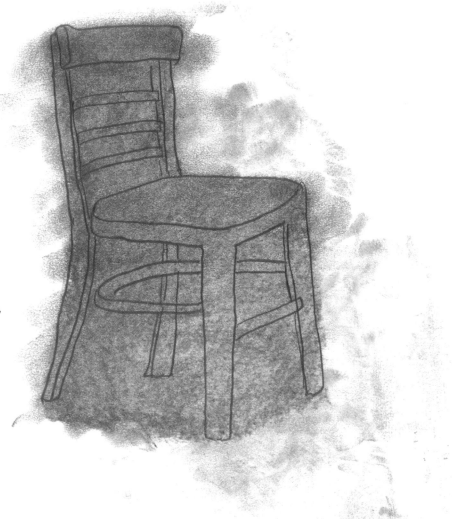

This is a good example of how the cloud helped control the size, position, and character of the now-revealed chair shape.

4 WIPING AWAY TO REVEAL THE IMAGE

After you have completed drawing the lines, wipe across the page with the flat of your hand, in the same way as you did earlier with the erasing and wiping exercise. Go ahead—let your hands get dirty. Wiping across the drawing has the effect of taking away the charcoal cloud and revealing the pencil lines more distinctly. If you did a good job in making a cloud shape equivalent to your object, your outlined drawing will look "right." If it doesn't look "right," that doesn't matter because you now understand how the process works. You know how important it is to be focused on "getting the shape" in the cloud phase. The cloud-making process helps teach you how to "see" what you are drawing, while the line, by clarifying the object, tests how well you made the cloud shape.

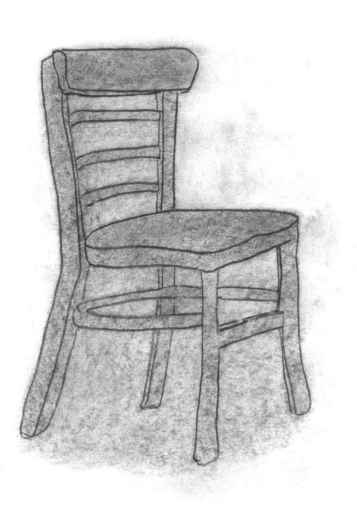

The process of working on the whole page keeps the drawing unified in the sense that, at any one point, you could stop and the whole drawing would function as an equivalent of what you are seeing.

5 ERASING THE CHARCOAL

After you have completed the linear phase of one of your drawings and have wiped through to reveal the lines, there will be extra charcoal "dirt" outside your image. With your eraser remove some of that smudged charcoal.

Use an overall approach, beginning with areas away from the edge of the subject of the drawing—the figure. Clean a little here, then a little on the opposite side of the paper. In this manner keep moving from area to area. When you work with an overall approach, the ground (for the moment, think of it as the background) should always feel unified. The same principle applies as before: try to avoid part-to-part ordering (see page 21), which involves proceeding from top to bottom, left to right, or right to left.

We work on the "ground" in this manner for the same reason we try to vary the marking when drawing the cloud—to maintain equivalence to what we are seeing.

The purpose of erasing

With erasing you have added a fourth stage to your process and another opportunity to define your shapes.

You can use your eraser

- to help define the shape of your cloud (the "figure") early on in the first stage;

- to clean up or "reclaim" the background (the "ground");

- to further define the object (the "figure").

Using your eraser in this way can help you maintain an integrated relationship between the "figure" and the "ground." The "figure" becomes part of the "ground," and now the "ground" can also be used to form the "figure."

For us, erasing does not have to function solely as a way of correcting or fixing. We can use it as an additive process equal to the use of charcoal or pencil. For example, we used it to reveal rather than fix what are considered "mistakes." It helped reclaim the "ground" of the paper. Like rubbing or marking on the "ground," using the eraser also reaffirms the flatness of the page and increases awareness of the relationship between the "figure" and the "ground."

The act of erasing the "ground" in order to further define the "figure" also serves as a foretaste of painting. Paint can be used to physically form shapes, be they "figure" or "ground." In a sense, drawing is more complex, initially, because when we draw with line, we are expecting ourselves to define the figure and ground simultaneously. We expect ourselves to draw one line and have it function as an edge for two shapes. For this reason I have always felt it would be easier to start a beginner with painting rather than drawing.

Creating stable shapes using the cloud

Working with the cloud also helps us to create stable shapes. A stable shape is one that appears solid and looks as if it exists in a real space. This happens when there is a dynamic "**figure–ground**" relationship between the object as the shape on the page (the "figure") and its surrounding field (the "ground"). An unstable shape, on the other hand, appears to float in a void and has no relationship to its ground. The cloud creates a solid, more stable shape on the page, a shape that defines its own edge. A dynamic figure–ground relationship is more likely to happen when the ground appears to form the figure.

At the opposite end of the scale, an unstable shape is usually made with outline. The lines appear to float in a void of space with no relationship to the surrounding field or "ground." You can tell because the line that forms the outlined shape doesn't function as an edge. Therefore, the shape it creates does not have a sense of volume or stability. In the next chapter, we will see how to combine the use of the cloud and mark-making (using lines) to create stable shapes.

Using the cloud for figure drawing

Drawing from simple objects — a shoe, a banana, a hat—seems much easier to us than drawing from the figure. There are a number of reasons for this. Of all possible subjects, the live model will elicit the most object-directedness. After all, everyone has a body. We have all grown up within our own unique bodies and are acutely aware of all their specificities. We "know" more about the "figure" than any other object. For us, it is charged with meaning. This explains why drawing the figure is considered the most difficult. The model is an alive, active, tactile, flesh-and-blood, physical reality present in the room, on the stand: a real person. How can a piece of charcoal (a burnt stick) ever account for so much complexity? And yet, the shape of a rock, for example, is just as visually specific as the shape of a person, but we don't see it because, with customary perception, we do not assign an equal value to the rock.

We try to draw according to this hierarchy of values, which is one explanation for the tendency to make unintentional distortions. For example, when drawing an object such as a table, we will always tend to draw more of its top than we actually see. The top of the table, to us, defines its meaning and purpose, and it is difficult for us to accept the degree of abstraction our eyes are seeing. Therefore we cannot help but show more of the top than we actually see.

In the case of the figure, the same happens when we draw the torso area much larger than the hip–leg area, even if that area happens to be visually larger. We do this for the same reason. With customary perception, we "know" the torso is more important to us than the hip–leg area, therefore we see it as larger. In a sense, we do not "know" the "shape of the space" for the hips and legs, so we cannot see how large it is.

We also tend to categorize our perceptions based on functions and values. Things that are similar are perceived as the same. In order to function in life, we have to assume that all those lines in the pavement are the same and all the telephone poles are the same and so on. However, with *aesthetic perception* there are no such hierarchies or common categorizations. Shapes are shapes. Our eyes see them for what they are, through "seeing" rather than "knowing." We must learn to see in terms of drawing, and that means being sensitive to the particularity of each shape — every line in the pavement is a different size, has a different location, and character, and each telephone pole is visually unique as well. Both eyes of the model are not the same, nor are the arms and legs, and so on.

Try this!
KNOWING THE FIGURE, SEEING THE SHAPE-OF-SPACE

To utilize the cloud technique with the figure, it is important to have a clear understanding of the difference between the figure and the pose. If we think of the figure/model as the known object, then the pose is the "shape" that the object presents us visually, from our particular viewpoint at a given moment. The shape presented by the same object or model will be different with each pose. It will also be different for every person in the room looking at the same model/pose, because each person is in a different position, with a different viewpoint. Of course this is also true for simple objects, but it is more dramatically obvious with the figure because the figure is an object that can move, take different poses, and thus re-form itself into a wide variety of different shapes.

For the cloud technique to be effective, you must learn to see the pose as the flat shape, the *shape-of-space*. It is a general shape that does not separate parts such as arms and legs, as well as the spaces between them. It includes the entire model within its edges.

Again, you will need a large piece of paper 18 x 24 in. (45 x 60 cm) in size, a piece of vine charcoal, a pencil, and an eraser.

USING THE EMPTY-HANDS TECHNIQUE

Have the model take a sequence of several extremely varied poses (a minute or two for each one). This will make it easier for you to see the unique character of each shape-of-space. Be imaginative and experimental—here are some poses to try:

• Standing with arms and legs stretched out, like Leonardo's *Vitruvian Man*

• Seated with arms folded and legs crossed

• Bent over like a baseball player fielding a ball

• Doing a plié like a ballerina, or some other ballet pose

• Kneeling down praying

• Seated like Rodin's *The Thinker*

• Curled up in the fetal position

Each time the model takes one of these poses, rub the paper empty-handed as if you were making a cloud drawing of the shape-of-space of the pose you see at that moment. These empty-handed drawings will serve as preview enactments of the real thing. You are teaching yourself what particular shapes are coming from each pose without actually marking the paper.

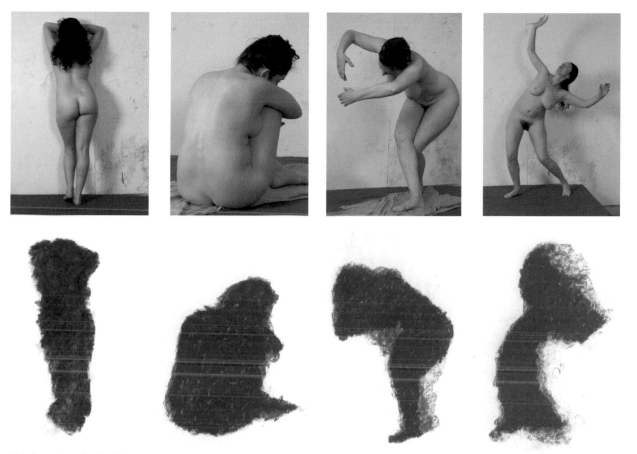

Note how dramatically different each "shape-of-space" is for each pose the same model assumes. The cloud shapes demonstrate varying degrees of success in drawing the shape without responding to the "parts" of the model.

2 BEGINNING TO SHAPE THE SHAPE

Once you have taught yourself what to look for, pick up the charcoal and begin to draw that shape-of-space. Again, as in our earlier clouds, all the parts should be present on the page right from the beginning. Try not to respond to the model but to the space his/her pose takes up on the retina: it should encompass everything—the entire model and the entire pose, including the spaces between arms and legs, etc. As your cloud emerges on the paper, there should be no evidence of individual parts, just a flat cloud, and yet there must also be enough space for all those parts within the edges of your cloud. The goal here is to become more conscious of this shape, no matter how primitive or bloblike, as a flat shape. This sounds basic and simple, but is very difficult. You are being asked to draw, in effect, a shape that does not exist "out there." You are being asked to draw the shape-of-space, but *without drawing the model*.

Questions to ask

Just as when you were drawing from simpler mono-shapes, stop drawing every few seconds and stand back to get a clear overall view of your paper. Ask yourself these questions:

- Is the shape I now have on the page, at this moment (after a few seconds of drawing), equivalent to the one I see coming from the shape-of-space of this particular pose?

- Does my shape include space for everything?

- Am I waiting to finish one area before going on to the next?

- Is there evidence of parts in my cloud, such as arms and legs? If so, rub over them to even out the cloud.

- Have I reverted to touching the model in my imagination? Use your viewfinder or make a frame with your hands, and look back and forth through it, from the pose to your cloud.

- Have I captured, in a general sense, an equivalent shape to the one I see, coming from the pose? If you do not have an equivalent shape, then smear it with your hands and try to reshape it to form an equivalent version.

3 TESTING WITH LINE

As with our simple cloud drawings, you can now use line to test how well you made your cloud with the figure, which is a much more complex image.

As before, start by drawing your lines on the outside edge of the cloud. Trust the cloud and let it guide you. Draw a line on the right side of the figure, then the left side, the top, and the bottom. You are defining the shape of the figure from the outside edge of your cloud. Then move inside and begin to define parts (arms, legs, etc.), using the same "this is the opposite edge to that edge" procedure. As you make the shapes of parts clearer, look for overlap opportunities and define them. Include as many parts as you can, from hands and feet to jewelry or glasses. Use only line to do this, no shading or shadows. Also, as before, maintain line constancy.

Do not go outside your cloud. Everything should be contained within its edges. For example, if you find that you did not include enough space for the legs, then distort them in order to make them fit inside your cloud. Your drawing may look terribly distorted, but the next time you will know better what to look for when shaping the cloud. Learn to trust the cloud stage as the most important and depend on it to guide you with your line/marking. The difficult part is establishing the character of the cloud. Once that is established, the linear phase simply defines the object, which exists inside the cloud shape and serves mainly as a test. The line reveals the object within the cloud and thus the accuracy of your "seeing" of the cloud.

4 ERASING

This fourth phase of erasing the ground may function more clearly for you than it did in the mono-object version. Continue to try to keep a unified approach when utilizing the eraser.

 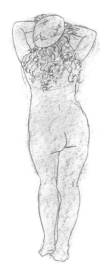

The addition of greater detail reveals a good rendering of the shape of the figure.

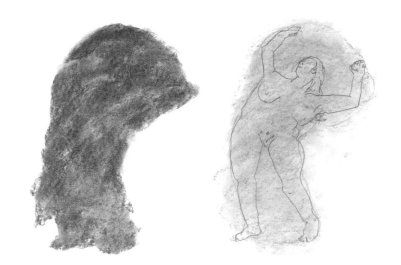

This cloud was too squat, so the figure is accordingly distorted.

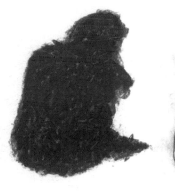 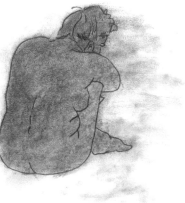

With just a very few details added inside the outline of the cloud, the drawing is already an accurate rendering of the model in this pose.

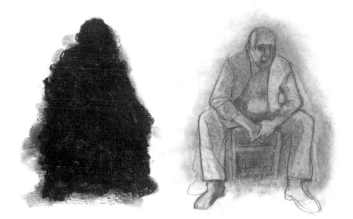

The addition of detail to the cloud has revealed a slight distortion of the position of the model's right leg, which the artist has corrected.

Some encouragement

Don't be surprised if your first cloud drawings with the figure continue to exhibit customary perceptual responses to the object. For example, there may be evidence in your cloud of arms and legs or of "shadows" and "highlights" and so on. Your cloud may appear to have been done from the top to the bottom, or from right to left. Or, without realizing it, you may have made a quick outline and then filled in the shape as if painting the surface of a wall. (From our point of view, this is cheating. Doing this reinforces the tendency toward part-to-part ordering.)

It is quite difficult to look at the model and not try to draw him/her. But that is the challenge: to look at the pose and to draw, from the inside out, the flat "shape-of-space" the pose is taking up from your particular viewpoint. The cloud emerging on your page is your response to a shape determined by the pose and not a response to the model as an object. It is not easy to see the model as an abstract flat shape taking up space on the retina. Our connection to the model as object is extremely powerful.

If you get frustrated or discouraged, try to see it as a sign that you are getting somewhere. It means that you are starting to understand the problem. Remember, a customary response is built into our very musculature. With continued attempts you will eventually learn to put more faith in what you see as "shape" and be less dependent on a customary attachment to the "object." Just continue to put faith in the process of "shaping," with your charcoal, the shape-of-space your eyes are seeing.

These exercises are designed, in part, to exhaust your ability to depend on a customary response to an aesthetic task. Eventually, you will just give up and start "seeing." First there is consciousness and later, through exercise, a change in perception.

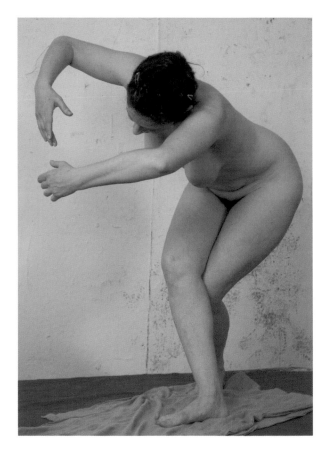

Benefits of using the cloud

The cloud is very difficult to "get" in the beginning. However, it is one of the most effective means of experiencing the difference between customary perception and aesthetic perception. Doing this correctly requires letting go of a three-dimensional, tactile attachment to the object. Instead of focusing on the object you must connect to the shape of the space the object takes up in your visual perception. Try to let the shape your eyes see come to you, and then try to shape that shape with your charcoal. This is not the general version of the object you have internalized through your customary perception but the specific (retinal) shape, the one your eye sees at that particular moment. To be sure, the object is the source of the shape but the version that

emerges on the paper is an invention unique to each person's point of view. If done correctly, in the same room, with the same object, each person will experience a shape specific to him or her—that same banana or human model will present a unique and different shape to everyone in the room.

Persevering with the cloud technique is ultimately very rewarding. The technique will teach you to see three-dimensional objects as two-dimensional shapes. Once you are able to do that, you will avoid making distortions, and that will mean that your drawings will start to look like the object/model in front of you. They will look more real and three dimensional and will feel more stable.

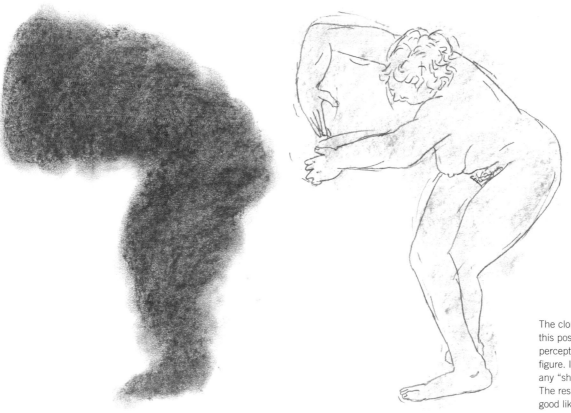

The cloud produced from this pose is free from customary perceptual responses to the figure. It is even and free from any "shadows" or "highlights." The resulting drawing is a good likeness.

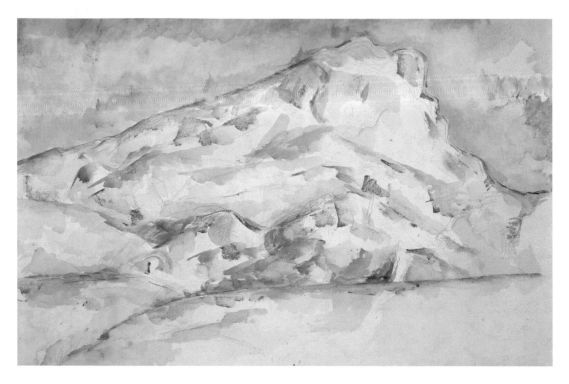

Paul Cézanne, *La Montagne Sainte-Victoire*, 1900–2. Pencil, gouache, and watercolor on paper. Musée du Louvre, Paris, Fonds Orsay (photo: akg-images).

This picture is one of many Cézanne produced of Mt. Sainte-Victoire, each a unique example of his response to the same subject.

66 Here on the banks of the river the motifs are teeming, the same subject seen from a different angle suggests a subject of the highest interest, and so varied that I could keep myself busy for months without moving from one spot, just by leaning now to the right, now to the left. 99

Paul Cézanne

See Gerstle Mack, *Paul Cézanne* (New York: Alfred A. Knopf, 1935), p. 389.

Making marks

- Use proximity as an organizing tool to imply a shape using marks. Cloud shapes can be formed with marks.

- Increase your sensitivity to and understanding of stable shapes.

- Further develop your response to drawing on the flat paper rather than on an imagined three-dimensional object.

The line-constancy and cloud exercises on pages 25–27 and 42–43 helped us experience the two extreme ways to make shapes on the two-dimensional plane: **outlining** and **shaping**. Between those two extremes lies an infinity of possible ways to create shapes by making marks. To continue our scale analogy, toward the lighter end of the scale, for example, would be a watercolor by Paul Cézanne. With an incredibly economic use of marks and a pastiche of colors, he was able to communicate his perception of a momentary view of Mt. Sainte-Victoire. And toward the darker, denser end of the scale would be a portrait by Van Gogh. Here, the artist has used marks like visual molecules to construct a two-dimensional model (in the scientific use of the word) of his perception of a sailor sitting before him on a particular morning.

In this chapter you will explore the vast range of possibilities that exist between these two extremes. In a way, making marks is truly the art of drawing. The individual signature of an artist and the depth and subtlety of his or her perception is most likely to be expressed through marks. Increasing your mark vocabulary will make a huge difference in the potential pleasure open to you in drawing. The activity of drawing, as well as your appreciation of drawing, will become richer, deeper, and more satisfying.

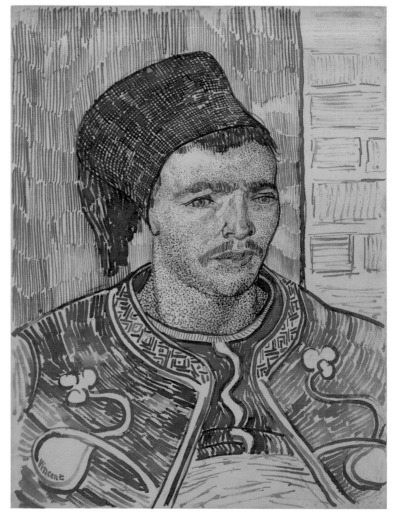

Vincent van Gogh, *The Zouave*, 1888. Reed pen, pen, and ink over graphite on wove paper. Solomon R. Guggenheim Museum, New York. Thannhauser Collection, Gift of Justin K. Thannhauser, 1978 [78.2514.23].

This drawing exhibits Van Gogh's vast vocabulary of marks. Each mark pattern has a consistent logic of character and intensity. It is due to his mastery of marking that Van Gogh was able to be so expressive when using color in his paintings. He could rely on mark patterns to make requisite brightness contrasts rather than muddying his colors with umber or black to achieve volumetric form by "shading" the edges of his shapes.

Paul Cézanne, *La Montagne Sainte-Victoire*, c.1885. Watercolor. Graphische Sammlung Albertina, Vienna (photo: akg-images/Erich Lessing).

This watercolor demonstrates Cézanne's incredible economy of means. The reason we can feel actually present there with Cézanne, looking at his mountain, is because we are able to empathize, in a physical way, with his marks and pastiches.

The difference between lines and marks

Every action you have been making with your pencil or charcoal on paper can be described as making marks. The critical difference between a line as an "outline" or a line as a "mark" is internal and qualitative. When using our customary perception, the hidden psychology behind the act of outlining is object-directedness: we try to "lasso" the shape by circumscribing it from left to right or right to left, which encourages an imaginary "touching" of the object (see page 16). Since our response is tactile and nonvisual, the resulting line will, very often, appear to lie on the paper like a piece of rope or spaghetti. You may be able to identify the drawn object, but the likelihood of its having an actual sense of volumetric form or spatial stability is nil. From our experience with the cloud, you know how to make stable shapes by shaping them from the inside out (see page 44). These shapes are stable because, in the process of shaping, the edges and the shape are happening at the same time.

Great artists such as Picasso, Matisse, Kokoschka, and others were able to draw solely with lines that functioned simultaneously as edges and shapes. This is why their outlined shapes have volumetric character and spatial stability. As you continue to develop your ability to "see" shapes, your lines will function similarly.

Note how the lines of this pepper lie on the paper like string or spaghetti. You can tell it is a pepper, but because the lines do not form edges, the drawing lacks a sense of volumetric character or visual stability.

The lines in this pepper drawing function much better as edges, and therefore the image feels more volumetric. These lines don't "float."

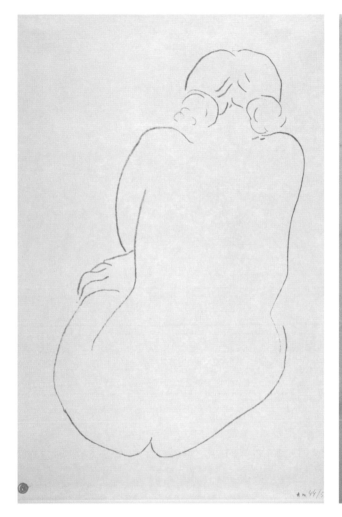

Henri Matisse, *Nu Assis, vu de Dos*, 1913. Drawing. Minneapolis Institute of Arts, gift of Edith and Norman Garmezy, 2000.283.1.

This beautifully drawn figure exemplifies Matisse's ability to achieve a sense of volumetric form without any shading, only lines. Note his use of line constancy and subtle line character.

Pablo Picasso, *Portrait of Erik Satie*, 1920. Drawing. Musée Picasso, Paris (photo: akg-images / Cameraphoto).

The lines in this drawing by Picasso function as edges for the shapes they define. This is because he saw the shapes that define the edges rather than seeing only the edges, and he saw that, most likely, before putting pen to paper.

Outline as continuous marks

By "outline" we usually mean a continuous line that attempts to define an object by circumscribing its contour. Until now, we have used line in this way: to capture and define the shape of the object/model.

Our customary perception causes us to think of line in this way. It comes from our tendency to imagine that we are touching the edge of an object as we draw it. Typically, we begin at the top, drawing clockwise from left to right or counterclockwise from right to left. Since we are "touching" the contour of the object, we can only guess what, where, and how big the shape will be on the page as we try to capture it. This process requires going from one point to the next—from *part to part*. When using line in this "linear" way, it is hard to teach yourself what the shape actually is as you draw. It is an object-directed versus a shape-directed approach, or a *customary* response versus an *aesthetic* response.

As mentioned above, once you get accustomed to seeing the whole shape-of-space you will be able to act the same way when outlining with your pencil; now, however, you will be making shapes with your lines, which will function as edges rather than float on the page like lengths of spaghetti.

Oskar Kokoschka, *Portrait of Adolf Loos* from *Der Sturm*, no.18, 1910. Drawing. Staatsbibliothek, Berlin (photo: BPK / Staatsbibliothek zu Berlin—Preußischer Kulturbesitz / Dietmar Katz).

The success of this drawing lies in Kokoschka's incredible ability to control the intensity of his lines/marks (note the slight variation of intensity to the lines in the jacket from the right side to the left side), his execution of clearly defined overlaps, and his use of mark variation and mark particularity (note the character difference between the marks he uses for flesh areas—the hands and the head—and the marks he uses for the jacket).

Marks as discontinuous line

Making a mark here and a mark there can form an implied or **discontinuous line**. The eye will "fill in" the missing spaces due to the phenomenon of closure. The advantage of using marks as discontinuous line is that they can be exploratory. They do not require an immediate commitment to the completion of the shape of the object. You can experiment while you are drawing to find your version of the shape's location, size, and character; you do not have to decide right away where or what the shape will ultimately be. Instead of proceeding from top to bottom in one long continuous "lassoing" of the object, you can proceed back and forth from one edge of a shape to its opposite edge, in effect "finding" the shape on the page. As you do this, your eyes

become accustomed to looking for and seeing the shape that creates the edges, resulting in lines/marks that are both more accurate and spontaneous. You are no longer "touching" the contour of the object ("out there") but, instead, concentrating on the emerging edges of the shape on your paper ("back here").

You are free to decide whether to complete the shapes with a continuous line or leave them open with discontinuous marks, depending on your intuition about the drawing. At any given moment in the process you can stop drawing. It will not matter how far along you are, for if you have been attending to the whole field, your drawing will have an overall sense of integrity.

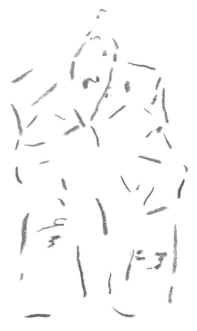

Just a few marks imply the shape of this vest. The open spaces between the marks/lines allow the possibility for change. True, the possibilities are limited, but you are free to make adjustments.

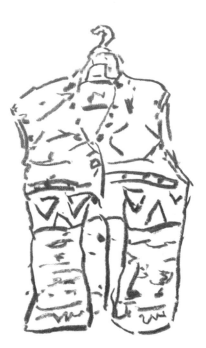

More lines have been added to define the shapes further, maintaining an overall sense of unity. The drawing could continue further to include as much detail as desired.

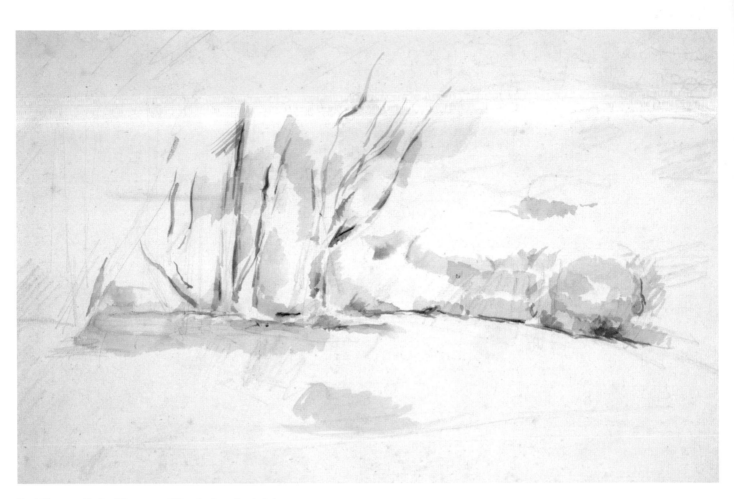

Paul Cézanne, *Study of Trees: La Lisière*, 1895–1900. Watercolor, pencil, and black chalk. The Whitworth Art Gallery, The University of Manchester [D.1927.16].

This mixed-media study by Cézanne demonstrates how the field is both open and dynamic. Discontinuous marks allow the field to remain "open," and our eyes fill in the coincident edges due to the phenomenon of closure.

Marks
as pattern

In this chapter you will learn how to make patterns of marks that combine to create shapes. This happens due to the phenomenon of **proximity**, a Gestalt concept of visual order. Things, shapes, and marks close together— in close proximity—are perceived as units. This is because the eye, when seeing things in close proximity, mentally fills in the empty spaces between them and gives meaning to the entity as a single, recognizable shape. For the purpose of drawing, this means our marks can be organized to form groups, which can function as shapes.

It is due to proximity that we see these two groupings of dots as sets of three and two. For example, we do not initially see the first group as nine dots or the second set as six dots.

When you make a mark on a flat piece of paper in an effort to understand the shape-of-space, you can imply that shape by distributing your marks in a configuration equivalent to the shape you are seeing. This is something akin to how ancient astronomers identified star patterns according to animal shapes. In a sense, you can make your own "**star patterns**" act as your cloud shape.

Imagine how you would represent the shape-of-space of an object you are drawing if you were only allowed to make three to five marks. Now imagine continuing with more marks. You would have to focus attention on the possibility of the shape's general character while marking. The configuration of your shape could exist, right from the beginning, because your mark distribution could always imply the whole shape due to the organizing principle of proximity.

Another advantage of using marks to create a shape is that you do not have to use "outlines." You can keep the drawing open (by keeping the shapes open) to possible changes. You can always complete the shape with an outline, but once you do, the possibility of making changes is greatly diminished.

Unlike the charcoal cloud process, these minimal clusters of marks can suggest the cloud shape of the pepper, but without being as destructive to the page.

As the pattern increases, you can progressively bring the image of the pepper from general to specific.

The idea is to use the process to teach yourself what the shape is as you add more marks.

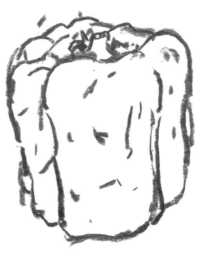

As the shape emerges on the page, it will be easier to make decisions. You can commit with line/marks to particularize overlaps and edges.

Finally, stop when the shape feels stable and volumetric, or when further marking would confuse the drawing. The process of using marks as clusters is another way to understand how drawing can go from open and general to closed and specific. As with the original cloud process, it requires concentration throughout and making adjustments along the way.

The cloud:
a tool for seeing

Earlier, when we combined the cloud with the line-constancy exercise, we established an order in which to make a drawing: first, find the largest shape; second, define the object with lines. This order establishes a good basic principle because it places your visual attention on the largest shape right from the beginning. It also emphasizes the idea of going from the general to the specific. If you can establish the general overall "largest" shape first, then drawing the parts becomes much easier, as the larger shape(s) will help in deciding where to locate lesser shapes. This is why we say, "The whole is greater than the sum of its parts." The large shape(s) show you where to put the smaller shapes (or parts) as compared to a customary perceptual approach where you proceed by adding one part to another and, usually, never achieve control over the whole.

We have used the cloud exercise as a device to learn to see the shape-of-space presented by the object or model to the retina (see page 45). By using the cloud to emphasize the two-dimensional plane, you experienced the stability of a shape that defines its own edge. The flat cloud served as a tool to help you "see" the object/model out there in three-dimensional space as a two-dimensional flat shape back here on the paper. To look at objects or models in this way can be difficult. But experiencing this truth about drawing also makes it more fun and exciting, because you begin to realize how inventive and personal it is to form two-dimensional shapes that have depth and meaning. The cloud is a good tool to help you find those shapes.

When we first used the cloud, you were encouraged to be aggressive with the charcoal (see page 44). Pressing down hard with the charcoal physically reaffirmed the flatness of the page. This, in turn, helped you to see as flat the three-dimensional shapes you were drawing. In order to make the function of this important tool clear, we needed to be blatantly obvious. Now that you have a better understanding of why we were doing all that "scribbling," you can use other methods to make your cloud. For example, it will not always be necessary to have really dark charcoal clouds. The function the cloud serves will always remain the same—to see three-dimensional shapes as flat shapes—but now you will learn to be more economical and use a lighter touch with the charcoal. A lighter cloud will make it easier to see what you are doing when you begin to define the images with lines or **mark patterns**.

Eventually, as you get more accustomed to knowing what to look for, you will become more efficient and require less information to find the same two-dimensional shape-of-space. At times it will not be necessary to make a cloud at all. You will simply see the shape, right from the beginning. Your marks will construct patterns that imply the shapes or, if you so choose, you can use a line and draw a shape at the same time (just like Matisse). This freedom, coupled with an increased vocabulary of marks, will greatly improve your flexibility and spontaneity when drawing.

I have great admiration for this watercolor by Cézanne. It is entitled *Foliage*—its subject is a single bush. In the mid-nineteenth century, this study would have appeared to be very abstract and thus difficult to comprehend. I empathize with the artist's desire to focus on a texture in this way, a challenge that would have demanded the greatest inventiveness in the use of his brush. In making this choice, it was as if he intuited the idea of a multiplicity of viewpoints with his pattern of marks, a concept that was not consciously realized until the Cubist period and the works of Picasso and Braque.

Paul Cézanne, *Foliage*, 1895–1900. Watercolor and pencil on paper. Museum of Modern Art (MoMA), New York, Lillie P. Bliss Collection 9.1934.a. (photo: © 2006. Digital image, The Museum of Modern Art, New York/Scala, Florence).

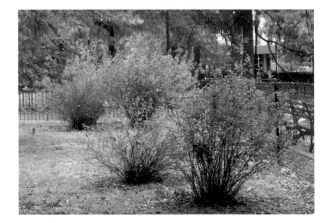

Bushes provide good subjects for exploring inventive marking. Their shapes are generalized and nebulous, so, in a sense, they are already abstract shapes made up of textural mark patterns. The following four drawing projects are meant to guide your use and development of marks as cumulative patterns. They work from simple patterns to complex, utilizing mark character, intensity, and size difference. They also help you to practice using the cloud as a tool to find the shape, and to introduce marking as an alternative means to make a cloud.

▌BUSHES OF THE SAME SPECIES

For this drawing, you will need a sketchbook, some vine charcoal, a pencil, and your eraser. Look for clusters of bushes, then find a nearby bench to sit down on, from which the bushes can easily be seen.

With your charcoal, make clouds of particular bushes, but with a lighter touch than before.

Next, use your pencil to mark on the clouds. Let the leaves and branches of the bush influence your marking. Try to maintain a consistent intensity to the marks.

Do several different bushes in this manner. Each time, allow yourself to be influenced by the "texture" of the particular bush you are drawing.

This drawing uses size and some brightness differences to give a dramatic sense of depth. Line / mark character has been maintained for species identity.

This student was able to maintain a particular mark character from bush to bush. If the marks are similar, the eye will identify them as the same, and therefore all of these bushes will appear to be from the same species. This drawing is also a good example of effective use of brightness, which adds to the sense that these bushes, of the same species, exist in a real space.

2 BUSHES OF DIFFERENT SPECIES
Look for a group of bushes of different species.

Invent a different mark pattern for each bush by allowing the particular species to influence your marking.

Maintain a consistent intensity of mark for each bush, but be sensitive to the unique pattern differences from bush to bush. The general shape of each bush may be indistinct. Therefore, the only thing that will distinguish one bush from another will be the character differences in your mark patterns. If you are consistent with the mark patterns you invent for a particular bush, the eye will identify them as that particular species wherever you put those same mark patterns on the page. In this way marks can function as a visual code. You have learned to control the intensity of the mark and now you are also controlling the character of the mark. (See **Mark constancy and character** on page 92 for a discussion of Oskar Kokoschka's *Woman in a Robe*.)

This student made an effective use of "light" clouds to help her locate the shapes, and she then tried to show a different character of marks from bush to bush.

Similar marks were used to make this series of bush shapes, yet the slight variation in character causes the eye to identify which bushes are of the same species, and the brightness and size differences from bush to bush help to locate them in space.

These simple flat-leaf plants appear to be located in different depths of space due to the brightness contrast from one to the next. This is reinforced, too, by the use of different sizes.

These two bushes were made with the same mark patterns. The marks for the bush in the foreground are both larger and brighter, due to heavy pressure applied with the pencil. Thus the combination of cues—position, size, and brightness—contributes to the illusion of depth.

3 EXPERIMENTING WITH "BRIGHTNESS"

Continuing to draw from a variety of bushes; you are now going to experiment with brightness differences from bush to bush.

Draw a bush, making your marks with a lot of pencil pressure to create a very intense pattern of marks.

Next to that bush, on the same page, draw another one of the same species, using a similar pattern and character of marks, but this time make the mark pattern very faint.

Draw a third bush, again of the same species, with a level of intensity that is midway between the other two.

All three should be identifiable as the same species but appear to be in different locations due to brightness variation.

4 USING BRIGHTNESS AND SIZE

First, draw a pattern of marks that represent a particular bush.

Right next to it, do another version. But this time, without changing the character of the marks you are using, make the marks brighter (darker) and the overall distribution of them larger.

Now, to the side of that larger shape, create a third shape smaller than the other two. Use similar but much smaller marks and make them very faint.

All three examples of the bush should look like the same species because the mark character is essentially the same from bush to bush, but they will appear to be located spatially in different places because of the brightness and size depth cues.

Van Gogh-like marks were used to make this drawing of three bushes of the same species. Note how the character of the marks is the same from shape to shape, yet the brightness, size, and overlap cues are employed to create a sense of space.

Mark constancy

As with the line-constancy exercise, it is important to be able to maintain a consistent intensity with your lines/marks. Because the edge of an object is always a persistent element in customary perception, you may feel tempted to overemphasize the marks on the edge as opposed to those within the shape. If you do this, you may end up with a version of the "railroad track" type of visual contradiction, as you discovered in the exercise on page 18. For example, if the lines or marks on the edge of a bush (or the trunk of a tree) are more intense than the interior marks between the edges, then the edges will appear closer because they will be brighter. It will be difficult for those overemphasized lines to function as edges, because the space between them becomes an empty void. Volumetric character and spatial stability of the shape are lost.

Should this happen you can:

- erase or wipe the lines to equalize them with the interior marks

or

- intensify some of the interior marks so they are at least equal to the intensity of the edge marks.

When drawing there is always more than one choice you can make to solve a problem.

With marks only on the spaces between the edges of these birch trees and none on their edges, the drawing at this early stage is already quite stable. It has some volumetric character and spatial integrity.

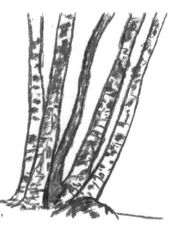

When the lines on the edges are overemphasized and overpower the marks between the edges with contradictory brightness, then stability is lost and the tree shapes begin to look flat and "in a void."

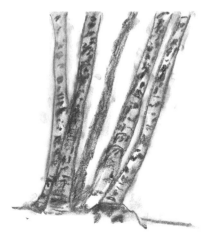

Some stability has been reclaimed at this stage. The drawing was wiped to equalize, and the interior marks were made brighter.

Trees present more opportunities to explore mark patterns, having the combined shape of the leaves, trunk, and branches. Practicing using the vertical form of trees will also make it easier to draw the figure later (see page 85). You can look at a tree as if it were a model adopting a pose. Start by thinking of this series of tree drawings as similar to the earlier cloud drawings of a chair (see page 44), only this time you will be drawing from trees rather than chairs.

I MAKING A LIGHT CLOUD FROM A TREE

Return to the park with your charcoal, pencils, eraser, and sketchbook. Sit down and look at trees.

Or, if you prefer to work inside and with bigger paper, this same exercise can be done from a series of pictures of trees you collect from magazines or that you have taken with your camera. You could even draw from projected images if you like. Working in a group from projected images is a good idea because it affords an opportunity to share and compare results of different people drawing the same objects.

Select a series of different trees. Look at them in a sequence as if each tree represented a different pose, as you did with the live model (see page 53).

Practice some empty-handed drawing of each tree cloud (see page 44) to get a feeling for the different shape of each tree's shape-of-space.

Now, with your charcoal, make a faint cloud drawing of one of the trees. You should strive to find the character of that particular tree's overall silhouette shape—you just won't be making the cloud shape as dark as before.

As with your previous clouds, space for everything should be included right from the beginning. There should be no evidence of parts such as leaves or branches or the trunk in your cloud, just the general silhouette—the shape-of-space the tree takes up on your retina. Many people, when first drawing trees, will respond with customary perceptual logic. They will "grow" the tree in a literal sense, starting with the trunk, then adding the branches, and finishing by putting the leaves on the branches. Don't do this! Even as a small spot-shape, that spot should function for you as an equivalent shape of the whole tree and should, at least theoretically, include space for all its parts

Begin small. Like an embryo, everything for your tree is contained within this nebulous shape.

Smudge the shape to even it out and "grow" the shape larger.

simultaneously, just as the exercise of growing a dot to a chair on page 44. If, in the early stages, there is evidence of identifiable parts, this indicates that you are not paying attention and have slipped back into a customary, part-to-part method. Eliminate the evidence by smudging and/or erasing to flatten the cloud, and continue.

Start to "grow" the cloud shape of the tree and *not the tree*. Toward the end, when the shape is as large as it can be, look for opportunities to define the character of the edges of your tree shape. The overall shape may be soft and so the edges might be curved, or if the branches and leaves are spiked, your shape may have some hard edges. You can use your eraser to do this. Giving character to the edges will make your silhouette shape emerge as a "tree."

Continue to increase the size, from the inside out, and begin to be more particular with the character of your shape. Make use of your viewfinder or "hands frame" to test this.

Now the shape is as large as possible while still fitting on the page.

Questions to ask

If you are still a little unsure about how to make the cloud, it may help to test yourself by asking the following questions while you are drawing:

• Is the shape I now have on the page, at this moment (after a few seconds of drawing), equivalent to the one I am seeing—the flat, planar, retinal shape?

• Do I have its shape-of-space?

• Does my shape include space for everything?

• Am I waiting to finish one area before going on to the next?

• Is there evidence of parts, such as branches and leaves, in my cloud?

• Have I reverted to touching the tree in my imagination, rather than the shape I see?

• Am I marking on the flat shape, or am I working on an imagined version of the tree?

Try using the viewfinder or your "hands frame" (as suggested when first learning to do the cloud on page 46) to see if you have captured, in a general sense, an equivalent shape to the one you are "seeing." If you realize that you have not, then smear the shape with your hands and try to rework it to form an equivalent version. If you like, you can also use your eraser to help re-form your shape by reclaiming it from the outside.

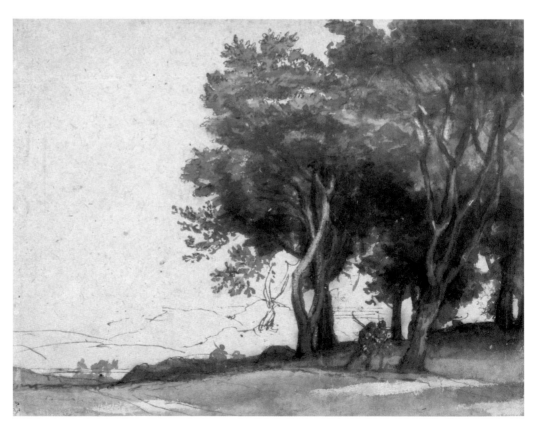

Claude Lorrain, *Étude d'arbres*, seventeenth century. Wash with browned ink and white highlights. Musée Condé, Chantilly, France. (photo: © Photo RMN – © René-Gabriel Ojéda).

For this wonderful pen-and-ink drawing, the artist most likely began with dabs of wash with his brush and marks with his pen here and there on the whole drawing to give himself a general sense of the location, size, and character of the shapes he wanted to draw.

Use the line to help define the character of the whole tree. The line can be discontinuous and somewhat open. Invent lines/marks based on the kind of tree it is. (This is similar to your mark invention with bushes.) The function of the line/mark phase is the same as it was for our original cloud-to-line usage. It reveals how accurate you were with the cloud by causing the object to emerge. The line/mark tests the cloud. The only difference is that, in this case, the object is a tree and your lines/marks can be more open and have more character!

This is a good example of how smudging the charcoal and erasing the ground can be very effective at keeping the drawing integrated and stable.

2 TESTING WITH LINE

When you have completed your shape of the tree, test it (as you did your earlier cloud on page 47) by drawing a line around the outside of the tree cloud to emphasize the silhouette. If you like, outline some branches and a few leaves as well. Remember to keep the intensity of your lines consistent, preferably the same general intensity as the cloud. This will keep the drawing unified.

Wipe across the drawing and use your eraser to define the "ground" (the background). If you see some "sky" inside your cloud shape, erase those areas to make them whiter (lighter) so they will "close" (merge) with the ground. You can outline them as well. When you have finished, your shape should have the overall feeling of the tree you are drawing. It should seem stable and not appear to float in a void.

The intensity of the marks in all of these drawings is generally consistent within each drawing.

The light cloud established the general shape character of this tree, which helped in locating marks. The marks for the leaf areas and trunk areas are similar but not the same.

By working further with marks, the tree image has emerged with more clarity and character. The marks have become more distinct from trunk to leaf areas.

After some wiping and erasing, this version of the tree emphasized the use of pencil marks over charcoal for a different detailed result. Either conclusion to the drawing of the tree is possible and legitimate.

3 MARKING ON A TREE CLOUD

Select a different tree and proceed, as before, to the point of completing the "light" charcoal cloud shape. This time, however, instead of outlining your cloud, you will make a pattern of marks with your pencil *on the shape*.

Let your cloud guide the distribution of your pattern and avoid following a top-to-bottom, "fill-in-the-shape" process. Rather, use an overall approach. Do a few marks on leafy areas, then a few on the tree trunk or branch areas, back to a leafy area, and so on. Allow the shape of leaves and bark to suggest the character of your marks. It is not important to draw every leaf or branch, but rather to evolve patterns of marks suggested by those areas: the trunk, the branches, and the leaves.

Try to maintain a consistent intensity in the marks, as before with the line-constancy exercise on page 26. (At this point, we do not want randomly to stimulate the brightness cue for depth perception. We will focus on its use with marking later.)

At any moment in the process, your mark distribution should be even enough to imply the whole "shape" of the tree. It should feel unified. Unlike the previous drawing of the tree, there should be no outlines on the borders of the shape(s), just patterns and/or clusters of marks that imply their edges.

Wipe across the drawing to reveal the marks more dramatically. If you want to, use your eraser to clean up some of the "ground" and reclaim light areas—such as the "sky"—within the patterns of marks.

4 MARKING TO FORM A TREE CLOUD

This time, select a different tree and work with a pencil. You will make a cloud using only marks. There will be no "light" cloud.

Make a pattern of marks that imply the shape of the whole tree. The process should be "scattershot"—a mark here, a mark there. Toward the end, emphasize the differences between the bark and the leaves with your marks.

Watch out for the following pitfalls:

- When drawing solely with pencil, you may revert to touching the object in your imagination. This often happens when returning to sole use of the pencil, because the point of the pencil implies precision, stimulating the feeling that you need to "find a place to put it." Instead, remember you are marking to form the shape-of-space, not the tree! This is the conflict: the internal battle is always between trying to mark on the page (aesthetic perception) as opposed to "imagined touch/marking" on the object (customary perception).

- Avoid a top-to-bottom, part-to-part progression. The whole shape should always be present on the page. Like an embryo, it may be small and nebulous, but it contains everything.

- You might also find yourself going to the edge of the shape first and filling in with a pattern second. This too is part-to-part ordering. Rather, try to look at the shape-of-space and develop an equivalent pattern on your page right from the beginning. Let the pattern imply the edge from the inside of the shape out. The shape will then define its own edge. It might help you understand this better if you think, The tree is always present as a whole object, therefore the shape I am drawing should also be able to be present as a whole shape (an equivalence), right from the beginning to the end.

All three of these drawings represent the tree at different stages and all three, as shapes, function as one-to-one equivalents to the shape of the tree.

The mark distribution for this fir tree is general but includes the whole cloud shape of the tree.

As marking continues, the tree's particularity emerges. The drawing could be considered complete.

Somewhat in the manner of Van Gogh, a massive number of marks have been used to complete this drawing.

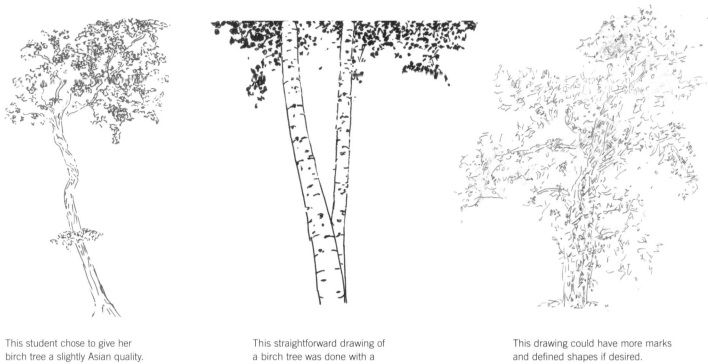

This student chose to give her birch tree a slightly Asian quality. It has good shape character and overall unity.

This straightforward drawing of a birch tree was done with a fine-point felt-tip pen. There is no "modeling," only marks and lines.

This drawing could have more marks and defined shapes if desired. However, at this point it has:

1. the overall character of the tree;
2. line and mark constancy;
3. a different mark character for leaf, trunk, and branch areas.

5 DEFINING WITH DISCONTINUOUS LINES

Now select another tree and proceed as you did in the last exercise to the point of finding the cloud shape by using pencil marks alone.

First, develop your cloud shape solely with marks. Again the process should be scattershot: a mark here, a mark there. Think "proximity."

After you have established your overall cloud, continue marking on the cloud to indicate the shapes of some areas of leaf and bark. Be inventive, making different marks for each.

As you work, throw in a few discontinuous lines on a shape's edge here and there. Rather than proceeding in a part-to-part fashion with continuous lines, seek opposing edges—remember, any perceived edge has an opposite edge. You are trying to form shapes from side to side. Avoid "lassoing" the shapes with a continuous circular outline. Try, too, to maintain an overall distribution of lines/marks on the various edges of the shapes; resist the need to complete the lines/marks on one shape before going on to the next.

As you mark, look for overlap opportunities and define a few of them, at the base of the tree or where the leaf shapes might overlap the trunk or branches, for example.

Stop when you feel the drawing has its own integrity.

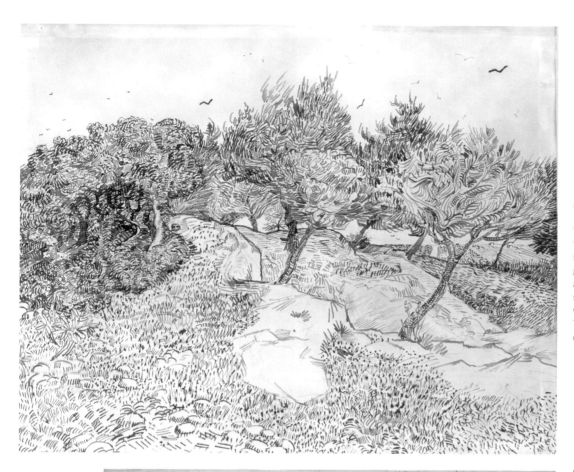

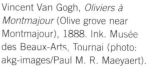

Vincent Van Gogh, *Oliviers à Montmajour* (Olive grove near Montmajour), 1888. Ink. Musée des Beaux-Arts, Tournai (photo: akg-images/Paul M. R. Maeyaert).

For this drawing of a grouping of olive trees, Van Gogh used a wide range of marks with clear mark integrity from area to area. The marks used for the leaves differ from those used for the trunk and branches, the marks used for grass differ from the stones and rocks, and so on. And yet with this tremendous variety of marks, the drawing maintains an overall sense of unity. The trees, rocks, gravel, grass, and even the birds all feel like they are in a real space. This was achieved solely with marks and mark patterns. There is no modeling in this drawing.

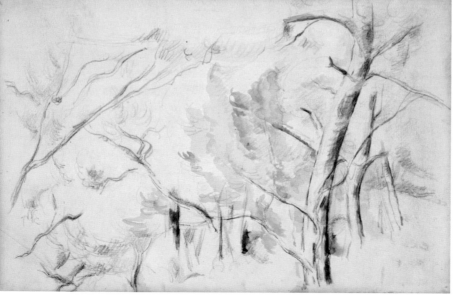

Paul Cézanne, *Woodside*, undated. Watercolor. The Barnes Foundation, Merion Station, Pennsylvania (photo: Corbis).

This is a good example of how to keep a drawing open to imply possible choices. You can see the brush's dabs of watercolor, the pencil strokes, etc., he used in order to "teach" himself what he was seeing. This study reveals how he may have approached the beginning of one of his oil paintings.

Using marks to draw the figure

In the previous exercises, we have used trees, bushes, and still life objects to develop our understanding and use of marks to draw shapes. These subjects have inherently implied marks or patterns of marks.

Now you are going to use marks to draw the figure. It may be difficult to make the transition, but you should know why this is so: the urge to put the point of the pencil on a particular place is strongest when we are drawing the figure. We "know" the figure more than any other object. We each have one. Therefore our customary perception causes us to be empathically connected to images of the human figure.

When making marks on the cloud shape of a figure, you must keep in mind the difference between the figure as an object and the pose as a shape. In the early stage of your drawing, it will be the "shape of the pose" you will be marking and not the model.

THE CHALLENGES OF THE CLOTHED FIGURE

The purpose of drawing from the clothed model is to give you as many opportunities as possible to invent marks. It makes it easier to see and draw differences if you have extreme contrasts in texture and shape to which you can respond. Have a willing friend dress in clothes that emphasize mark variation: a hat or scarf, a shirt or blouse with folds and patterns, pants with suspenders or a billowy skirt, distinctive boots or slippers, etc. In other words, costumes.

If you were to get together with a group of friends, each person could bring a different outfit and take turns modeling. This would be the easiest way to have a wide variety of images to draw from. In addition to being able to share and compare results, working in a group gives a supportive energy, making drawing easier and more fun.

This model provides a variety of shapes and textures to which to respond. There are many opportunities for mark variation from hair to hat, to her features, the scarf and blouse, and so on. Inventing a different feeling for the marks you use for the different areas would be challenging and fun. In addition, the overlap cues are numerous: hat over face and hair, hair over face and blouse, arms and hands over knees and blouse, etc.

Collect together your 18 x 24 in. (45 x 60 cm) paper, pencils, charcoal, and erasers and organize them on a table. Seat your costumed friend on a chair, in a relaxed, natural pose.

❙ PRACTICING SEEING THE SHAPE-OF-SPACE

Do some "empty hands" work and rub the shape-of-space of the pose. Empty-handed rubbing serves as a preparative enactment of the drawing—in your mind, you will be considering possible shapes and mark patterns.

Questions to ask

As you feel the flatness of the page, ask yourself questions like:

- Does this imagined cloud include everything I want in the drawing from head to toe, even the chair?

- What is the largest shape within the cloud?

- How do these shapes relate to each other in terms of size, brightness, overlap, and position?

- What kinds of marks shall I use for this shape versus that shape?

- What level of contrast (or mark intensity) do I feel like using?

By asking these questions, you will in effect be developing a strategy for the drawing without actually doing anything to the paper.

2 SHAPING YOUR SHAPE

If you feel insecure about finding the shape, begin working with your charcoal by making a light cloud shape of the whole pose, as with the second part of the tree-drawing exercise on page 76. In the beginning, respond only to the space the pose takes up on your retina, not to the model. Remember that you have a three-dimensional shape out there (on the model stand), but a flat silhouette shape back here (on the page).

3 USING YOUR CLOUD TO BEGIN MARKING

Once you are confident that your flat-shaped cloud is equivalent to the one you are seeing, pick up your pencil and start marking. Let your cloud guide the distribution of marks on the page. Do not mark outside your cloud—all of your marks should stay within its borders. At this point there should be no outlining of shapes.

Allow the separate elements—the items of clothing as well as the body—to suggest different marks. As in previous exercises, move rapidly from area to area, without closing off one shape before going on to the next. Resist the temptation to work sequentially from one side of the paper to the other. At any moment in the process, your mark distribution should be even enough to imply the overall shape of the whole subject, including the chair. It may not be complete, but should always feel unified. In the same way that the whole image of the model and chair is always present, you also have an equivalent shape on the page that is always present.

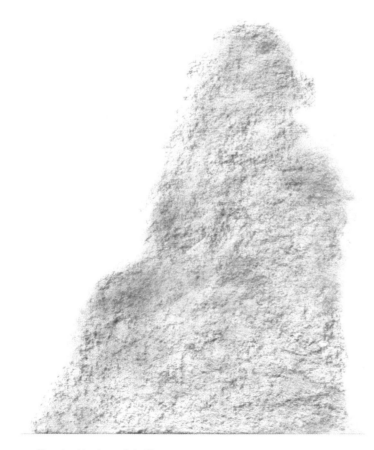

The cloud is always flat with no variation of tone. It includes everything in a generalized way, even potential so-called negative space.

4 DEFINING EDGES

Begin to throw in a few discontinuous marks on the edges of shapes here and there. Remember to look for opposing edges and "shape the shapes" with your lines and marks.

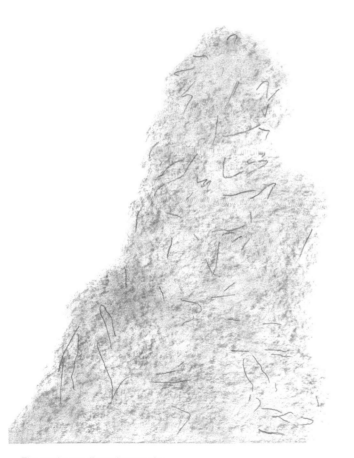

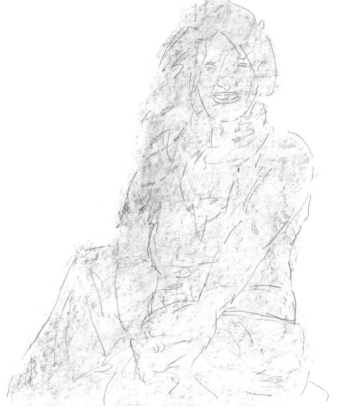

The marks are discontinuous, the shapes of the figure have yet to emerge, and yet the consistent intensity and distribution of the marks are already lending the shape a sense of spatial stability.

Some discontinuous lines and marks have begun to "find opposing edges." Shapes are emerging.

5 CLARIFYING AND COMPLETING YOUR DRAWING

Look for overlap opportunities and define them. The hat should overlap the face, the hair, and her ear. The hair should overlap the face, the chin, the shirt, and so on.

Toward the end, as you near completion, work hard to clarify as many of the different shapes as possible. As always, feel free to use your eraser to clean up and reclaim areas, including the ground.

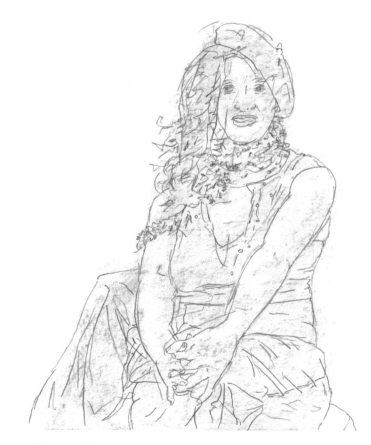

Marks and lines have been committed. Overlaps have been defined. Note the difference in feeling of the lines on the flesh areas as compared to the marks on hair, cloth, etc.

Questions to ask

Put your drawing(s) up on the wall and ask the following questions:

• Is there an overall sense of integrity to the drawing?

• Does it feel unified and spatially stable?

• Do the shapes you have invented display mark difference from one area to another?

• Are the marks used for the same object(s) consistent enough for the eye and the mind to identify them as similar or the same?

• Are there clearly defined overlaps?

• Are most shapes both overlapping and being overlapped?

Try this!
DRAWING FROM THE NUDE MODEL

This is the ultimate test. If you can look at a nude figure and mark on the shape-of-space without touching the model in your mind's eye, it will mean you have overcome the conflict between customary perception and aesthetic perception—you are free! But if you can't do this, don't worry: no one really can achieve this completely.

Ask a willing friend to pose for you. Have them remove their clothes and take up a standing, relaxed pose, similar to the ones you did for your cloud drawings in Chapter 3 (see page 52). The goal here will be similar: to draw the whole figure as large as possible and yet have it contained within the paper. The marking process will test your ability to locate the whole shape by "marking on the shape of-space" and not on the figure (in the first stage of the drawing). Use the same materials you used for the previous exercise.

Questions to ask

As you feel the flatness of the page, ask the following questions:

- What are the characteristics of this pose, from my viewpoint?

- Will the shape I need to make be tall and narrow or short and wide?

- What qualities are most obvious?

- How much space does the area for hips, legs, and feet take up on the paper compared to the area for torso, head, and arms?

- What position are the hands and feet in (as shapes on the paper, not as body parts)?

❚ EXPLORING THE SHAPE

Begin by doing some empty-hands practice. Rub the shape-of-space of the pose. Resist the feeling that you are "touching" the model. When making the cloud you must focus on *the shape of the pose* and not so much on the model.

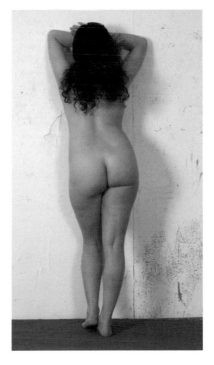

It is a good idea to start with poses that are simple and closed like this one. As you get used to working from the nude model, you can increase the degree of openness of the poses. Arms can be stretched out and feet placed apart. This will make the cloud much more abstract. The difference between the model as an object and the pose as a shape will be more extreme. You will be required to draw empty spaces as part of the cloud.

As always, the cloud supports the marking. Trust the cloud.

A little wiping to reveal the marks will help you to make overlaps and close some shapes.

2 SHAPING YOUR SHAPE

Start by making a light cloud of the pose. Then be brave and use your pencil or the tip of your charcoal to make a few marks to establish the overall shape-of-space of the pose. Think "proximity": you are making your own "star configuration" to imply the overall shape. In the beginning, respond only to the space the pose takes up on your retina, not to the model!

Once you are confident that the marks provide enough information for you to "see" the overall shape of the pose, begin to use a few discontinuous marks on the outside edges, remembering, as before, to seek opposing edges. Use an overall approach and move rapidly from one area to another, maintaining a consistent intensity. Don't avoid difficult areas such as the head or face, hands and feet, even if it simply means using very few marks. If you avoid them at the beginning, it can be very difficult to come back and complete them later.

3 ADDING DETAIL

When you have enough information on the paper to feel confident with the overall character of the image, then commit. Draw as much detail as you want. This can mean completing an outline, the eyes, mouth, ears, even earrings.

If you like, use your eraser to clean up and reclaim areas inside as well as outside the image of the figure.

Finally, commit and close the shapes. You are done. If your original cloud was not a good one and your image of the model looks distorted, then for the next drawing you should try harder to concentrate on the shape of the space the pose takes on the page.

Although this whole process can take place within a very short period of time, even as little as a few minutes, the principle of working from the general to the specific, and open to closed, remains the same.

Questions to ask

Put your drawing(s) up on the wall and examine them, asking the following questions:

• Have I defined the overlaps?

• Is there line/mark constancy?

• Is there line/mark character?

• Does the body hair have a visually consistent mark character?

• Have I been able to include shapes for the hands and feet that at least imply fingers and toes?

• Does the drawing have an overall sense of integrity?

• Does the drawing "feel" unified?

• Does the figure feel as if it is in a real space, or does it seem to float in a void?

Even if you achieve only half of these, you deserve to give yourself credit, for this is the most difficult challenge.

Mark constancy and character

The sequence of exercises in which you've made drawings of different still-life objects—trees, bushes, and figures—has challenged you to understand the use of marks in making shapes, and encouraged you to be inventive in making them. By now you should also know what it means to maintain mark character from one shape to another.

Oskar Kokoschka's drawing *Woman in a Robe* is a good example of how an artist is able to maintain the integrity of marks from area to area. For each identifiable part—the body, the hair, the robe—he was able to invent and use marks that maintain a particular character for each separate area. The differences may be subtle—as with the body and the robe—or they may be dramatic—as in the marks used for hair—but the character integrity is there. With beautiful economy, Kokoschka was able to create clear shape identity from area to area. The lines he used for the gown were similar to the lines he used for the body, but different enough to cause the eye to identify the difference between the two. For example, it is due to this subtle mark character integrity that the gown feels translucent.

This level of complexity cannot be achieved with an imagined tactile response to the model. It requires *drawing by seeing*. However, you do not have to be as practiced or experienced as Kokoschka to utilize the same visual logic. As long as your marks are consistent for similar shapes, the eye will identify them as belonging to the same shape. The mind will be able to differentiate between those shapes no matter the degree of abstraction or distortion. This is one explanation why a broad range of artists, responding to the same subject, can produce equally convincing yet wildly different drawings.

Oskar Kokoschka, *Woman in a Robe*, undated. Drawing. Private collection.

Note the variety of marks used to give character integrity to each area of the drawing.

Expanding your mark vocabulary

To go from a linear, object-directed process to a shape-directed process is when drawing can be most challenging. You may feel a bit lost. After all, how do you draw "things" without outlining them? When drawing the leaves of trees or bushes for the first time, for example, you may feel the impulse to outline each one. The same can be true when drawing a building, when you feel the need to outline each brick. Attempting this can drive you crazy! The solution is to expand your mark vocabulary so that you have a kind of visual shorthand to use to denote different shapes and textures in your drawings.

Consider researching the language of marks, using art as your primary resource. Look at artists' versions of the items you want to draw. These drawings are the best source because the artists have already converted known identifiable subject matter into marks and shapes. When you look at their drawings, you can see how they invented marks to create the illusion of recognizable objects. Learning how to make marks and create shapes that translate into water, cloth, faces, landscapes, trees, and bushes is revelatory. Go to museums, look at books of drawings, and study how inventive each artist is with the marks he or she makes.

• If you want to learn how to draw water, look at the drawings and prints that include water by different artists. Most people with a customary perceptual response will typically draw water the way they know it to be, as a liquid. They will make flowing "watery" strokes with their pencils. In actual fact, the best way to draw water is with hard edges. Waves and reflections are most often flat, abstract shapes with defined overlaps. Look for the shapes that cause you to see the waves, reflections, etc.

Katsushika Hokusai, *Kirifuri Fall at Kurokami-yama in Shimotsuke Province*, c.1831–32. Color woodblock print. Minneapolis Institute of Arts, bequest of Richard P. Gale 74.1.240.

This highly abstract woodprint by Hokusai reveals the possibilities when drawing water.

Rembrandt Harmenszoon van Rijn, *Ganymede in the Eagle's Clutches*, c. 1635 (study for the painting in the Gemäldegalerie Dresden). Pen and brown ink. Staatliche Kupferstichkabinett, Dresden (photo: akg-images).

This small pen-and-ink sketch serves as a study in mark variation. For example, the contrast between the heavier marks on the left side of the wings and the lighter, thinner marks on the right adds to the spatial depth and the drama of the subject.

- Consider the drawings of Van Gogh, Manet, Rembrandt, Delacroix, Corot, Mondrian, and Gorky. They were all masters at mark invention.

- Do some drawings in which you imitate an artist's particular marks. The fun of working from other artists' drawings (and paintings) comes from experiencing the magic of the illusions they have created—and you may feel relieved from the responsibility to invent your own. Copying master paintings and drawings has been a respected method to develop skills as a painter both in Western and Eastern traditions. There is an old saying about painting that still holds true: "You do not learn to paint (draw) from nature, you learn to paint (draw) from painting." Or, in our case: "You learn to draw from drawing."

Édouard Manet, *Les Courses* (The Races), c.1869. Drawing. Minneapolis Institute of Arts, gift of Bruce B. Dayton, by exchange P.86.28.

The energy, variety, and character of the marks accounts for the feeling of being there, in the moment. Note how marks are layered over other patterns of marks.

Eugène Delacroix, *Royal Tiger*, 1829. Black chalk on heavy off-white laid paper. Minneapolis Institute of Arts, gift of Marion and John Andrus, 91.131.1.

Note how the marks for stripes on Delacroix's tiger are actually specific shapes. The intensity of the marks on the interior shapes of the tiger is equal or "brighter" than the intensity of the lines on the edges of the shapes. Points of intersection are not overemphasized.

- Look at and draw from cartoons. With cartoon art, there is often little or no modeling and few half-tones used, so all the shapes are created with the most economic means. The expression of shape character and definition of overlap is very accessible in cartoon art. For example, if you don't know how to draw eyes, nose, and mouth configurations, look at cartoon versions. They are particularly helpful for this, as well as showing the relationship between fingers and hands or toes and feet.

Roy Lichtenstein, *Study for "Tension,"* 1964. Pencil and colored pencil on paper. Museum of Modern Art (MoMA), New York. Gift of the artist. 120.2004. (photo: © 2006 Digital image, MoMA, New York/Scala, Florence.)

In customary perception, we tend to see edges as lines, not as shapes. Everything in this sketch is a particular shape— the eyebrows, nose, hair, even the edges that define the faces are actually thin shapes, not lines. Well-defined overlaps, size and brightness differentiation, and shape character all make this drawing convincing, volumetrically and spatially.

Keep a sketchbook

Keeping a small sketchbook with you is a good habit. Whenever you have a moment in a park or waiting for a bus or any other situation that involves waiting, take advantage by doing studies of marks. Marks can be compared to notes in music; however, unlike a musical scale, the range of perceivable marks is limitless.

- Exercising your mark-making will increase your spontaneous responses when you draw. You should practice marking every day.

- Challenge yourself, and see to what extent you can create shapes with marks, particularly from objects or things that do not have any explicit texture or surface variation. Initially, do this without outlining the edge.

- Everywhere you look, every object, every surface can suggest mark possibilities to you.

- The same object can provide multiple ideas for marks.

- Every day is new. Therefore, your perception of the same thing(s) will change from day to day. This truth is what will keep your involvement with drawing alive and rewarding.

The baroque exercise

- Begin to look at the wider view in front of you, rather than concentrating on one object, by developing your use of peripheral vision.

- Understand how light order affects the distribution of lights and darks on the objects in front of you.

- Learn to identify and make a dark, light, and middle tone in your drawings to use that understanding of light order and add depth to your drawings.

In the course of this book, our subject(s) has developed from single objects, such as chairs, bushes, trees, and figures, to the simple still life or groupings of bushes. We have progressed in this way for a reason. With customary perception, as we now know, the tendency is to be object-directed. This means we usually look from object to object according to our attention or interest at a given moment. That is why we want to go from part to part when we draw. We began with single objects and have been moving toward combinations of objects to take us gradually from the local view to a broader overall view. We learned the necessity to look at the whole page with the line-constancy exercise and to see the overall character of a shape with the cloud exercise. With the development of marking we went further with more complex relationships between shapes and the use of marks. Thus the progression of our exercises has been from part-to-part, object-directed looking, to a broader overall way of looking. With the baroque exercise we will expand our seeing by explicitly addressing the use and need for **peripheral vision**.

The baroque exercise is named after late sixteenth- and seventeenth-century European artists such as Caravaggio, Rembrandt, and Georges de La Tour. It consists of a sequence of two drawings, which effectively demonstrate how **light order**—the distribution of light and dark—functions to organize the field.

With our customary perception, we examine objects according to our attention or interest. When we focus on a particular object, it is easy for us to describe its visual characteristics in great detail. However, were we to look past that same object and see it as part of a whole field, it may manifest entirely different visual qualities of color, texture, lightness, and darkness. Thus we have the difference between local viewing and peripheral viewing.

These two ways of looking, part-to-part (local) and field-oriented (peripheral), reflect a historical comparison. Very simplistically, think of the Renaissance artists as preoccupied with discovering and examining nature. They were asking questions like "What is this thing?" "What makes it look this way?" "How do I draw or paint nature to look like it looks?" The Baroque period addressed the next stage of observation by asking, "How do I see nature in the first place?" The Renaissance artist examined the thing and the Baroque artist examined the light that made it possible to see the thing. Thus, in essence, we went from a part-to-part (local) form of seeing in the Renaissance to a field-oriented (peripheral) way of seeing in the Baroque.

To make a further comparison, imagine a Renaissance artist—let's say Leonardo da Vinci—scrutinizing a hand and trying to draw it. He would study its specific characteristics as a hand and might even dissect it to examine its internal anatomy and so on. The focus would be on the hand as a separate, distinct entity.

Now imagine a Baroque artist—let's say Caravaggio. In addition to scrutinizing the same hand in a way similar to da Vinci, he would also be studying the quality of light coming through the window or from the candle and how it affected his perception of the hand, because that light makes it possible for him to see the hand in the first place.

The change in consciousness from an examination of an object as an identifiable, everyday, discrete item—a hand, a foot, a jug, etc.—to the method by which we see it is huge. In order to make choices based on the distribution of light, the artist must stand back and examine the whole field. Thus, in addition to content, light order itself becomes the subject of study for drawing or painting. Awareness of light order requires a distancing from the object. This characteristic of stepping back in order to examine the structure of light is similar to the necessary distancing we will discuss in the next chapter on landscape. Both concepts require looking at the field with peripheral vision.

Caravaggio, *Christ at Emmaus*, 1598. Oil on canvas. National Gallery, London (photo: akg-image/Nimtallah).

This painting clearly shows how light order was used to enhance the drama of Baroque period paintings. There is some modeling, however—the predominant means employed is based on light order, traditionally referred to as chiaroscuro.

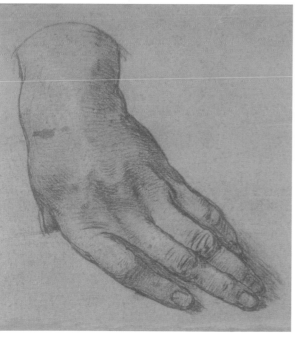

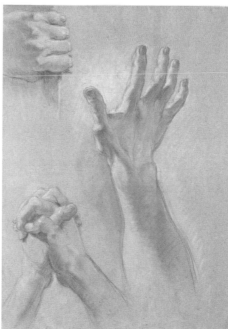

Far left: Leonardo da Vinci, *Study of a Left Hand*, c.1480–1515. Red chalk. Royal Library, Windsor (photo: Alinari Archives/Corbis).

This beautifully rendered hand exemplifies the study of anatomy by Renaissance artists. Modeling and making gradations of dark to light from the edge of shapes were important methods employed by the artists of that time.

Left: Italian School, *Study of Hands*, seventeenth century. White and red chalk on gray paper. Musée Bonnat, Bayonne (photo: © Photo RMN – © Gérard Blot).

Note the difference in this detail of a hand by a Baroque artist from the study (far left) by da Vinci. In addition to anatomical correctness, the structure of the light order and how it defines shapes is extremely particular.

Using peripheral vision to help see light order

It can be very difficult, at first, to see the difference between the local (or actual) color value of objects and the way that they look when viewed with a particular light source. We are not used to seeing the abstract shapes caused by the light order. Those shapes are separate from the objects. For example, it is not easy to see an object you know as primarily white as almost entirely black, which it might be when seen within the dark field of a strong light source. Our tendency to look at objects as separate from each other makes it difficult to look at lights and darks as they affect the objects within the whole field of vision. Even within a strong light-ordered environment, the objects will remain locatable if you were to focus on them. Therefore you may need a technique for looking that will aid in your ability to see and experience the light order and how it affects the objects within the whole field.

Here are some techniques that will help you see with peripheral vision. You can even practice them without drawing, while sitting in the park, riding in the car or train, etc. (Obviously, avoid doing them if you are actually driving the car or riding your bike. You could have an accident.) I also encourage you to have a sketchbook with you at all times, as you will most likely want to test your peripheral vision with some sketching.

USING A FOCAL POINT

Look for visually dramatic environments, places with obvious darks and lights. You are more likely to find them at night. During the day, look for predominantly dark spaces. At home, for example, you could experiment by turning off all but one lamp in your room. Let's say a lamp with a shade on a table. Now locate a particular spot on the wall somewhere behind the lamp, but not too close to the lamp. It might help to put a little piece of tape or paper on that spot. Now, while sitting comfortably on the other side of the room, use that spot as a place to focus your eyes. While maintaining focus on that spot, without letting your eyes wander, try to see the whole view as much as possible. Resist the urge to look at the objects on the table or the lamp. This practice is designed to subvert the *customary* tendency to "look out at the scene." Try, instead, to let the scene come to you, into your eyes. Stretch your peripheral vision as much as possible. You are using your "spot" simply to keep your eyes from wandering. Relax and begin to make judgments based on your overall (peripheral) vision. You should become aware of the dark and light abstract shapes.

USING YOUR VIEWFINDER OR YOUR "HANDS FRAME"

Mask off what you are seeing in the shape of a rectangle similar in proportion to your drawing paper. Doing this rather old-fashioned act can help make it easier for you to see the light distribution. Sometimes it helps to close one eye and/or to squint.

SWITCHING YOUR FOCUS

Switch your eyes from the spot on the wall to an object on the table and then back again. This is a good practice, to go back and forth from a peripheral view to a local view, as it helps make you aware of how the same object can look so different. For example, when you focus on a particular object in the "still life," it may appear to be white, but when looked at as part of the field view, the same white object could be in the dark field and therefore appear black. Locally it is white, but peripherally it is dark.

With the lamp off, an even distribution of light emphasizes the "local" color/tonality of each separate, discrete object. The wall, countertop, apple, and plate are all essentially white or light. The lamp is middle-tone and the avocado is dark.

With the lamp on, the light order is no longer related to the discrete objects. For example, the dark field includes the lampshade, most of the wall, part of the countertop, the lamp base, most of the avocado and apple, and a shadow shape under the plate. The brightest areas are in the vicinity of the light bulb. The light spills out on parts of the wall, countertop, and plate.

Letting your eyes rest on the "focus spot" and using your "hands frame" or viewfinder will aid in seeing the dark–light order.

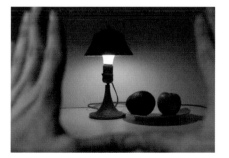

Questions to ask

- What and where are the objects?

- How is the light affecting the objects?

- What areas suggest the brightest shapes?

- What constitutes the largest shapes on the field?

- How might I divide the field into shapes as a dark, a light, and a middle tone? (Usually when there is a single light source, both the brightest and darkest areas are in close proximity to the source of the light. And, generally, the intensity progressively diminishes away from the light source.)

- If I were to divide this field into energy areas, which would be the most intense, the least intense, and which could constitute a middle range of intensity? (Thinking of areas as "energy" is just another aid in experiencing the light distribution.)

- Were I to make a drawing of this scene, what possible overlaps are suggested? (Be particularly aware of how the darks and lights overlap each other as separate shapes from the objects in the still life.)

- What kinds of mark patterns are suggested from area to area?

Dark, light, and middle tones (D-L-M)

The cloud serves as a tool to aid in seeing the flatness of three dimensional shapes. It works especially well with single shapes such as the figure, trees, etc. But with larger groups of objects we need a way to organize more complex combinations. The concept of a **dark**, **light**, **and middle tone** relationship is an organizational tool particularly suitable for more complex images. Like the cloud, it does not actually exist "out there" in nature or on the modelstand, but only as a relationship you impose and construct on your drawing paper. Becoming sensitive to potential tonal levels will increase your flexibility in organizing complex fields.

Finding a middle tone means making a comparative visual judgment based on a view of the whole page and its tonal extremes. You have been doing this already, for example, when you drew your version of a line to shape scale on page 28. You established the two extremes: an outlined shape (light) and a shaped shape (dark). Then you drew the middle square between the two. You made a comparative judgment so that its tonal value was midway between those of the dark square and the outlined square, and hence could be called a "middle tone." Likewise, when you used intense marks to draw the large bush and light marks on the small bush, but gave a medium level of intensity to the middle-sized bush, you were doing the same thing.

When a middle tone is achieved, the eye and the brain experience visual unity. This is because the middle tone functions midway between the tonal extremes and thus brings them into balance, unifying the whole page and making it visually accessible. With no middle judgments and shapes that are simply dark or light, big or small, the drawing would feel incomplete, or too "flat."

Georges Braque, *Statue d'Épouvante* (Still life with guitar and film program), 1913. Collage, charcoal and gouache on paper. Musée Picasso, Paris (photo: akg-images/Archives CDA/Guillot).

The use of D-L-M in this cubist collage is very clear and illustrates how context can determine the D-L-M relationship in different areas of the same image.

When you focus on the bright shape just above the guitar, the brown shape to the left functions as the dark tone, putting the guitar shape in the middle tone.

When you focus on the guitar shape, the black shape at the bottom puts that same brown shape above it in the middle tone.

With a pencil or charcoal, draw the outlines of three squares, as with our line-to-shape scale. They can be as small as 2 x 2 in. (5 x 5 cm). Make the right-hand square completely black/dark and the left-hand one with an outline, leaving it completely white. Now, make the center square a middle-toned gray, halfway in tone between the other two. (Hint: it is better to err on the side of being too light, as it is easier to make it darker if necessary.) If you make the middle square too light it will "close" with the white square, if too dark it will "close" with the dark square. Experiment by making the first attempt obviously too dark and then make the second one obviously too light. The third time you will have it perfectly in the middle. Once you achieve this balanced middle tone, you have experienced the concept. All middle tones are determined by making similar relational judgments—what actually functions as a middle tone, within a drawing, is relative to context.

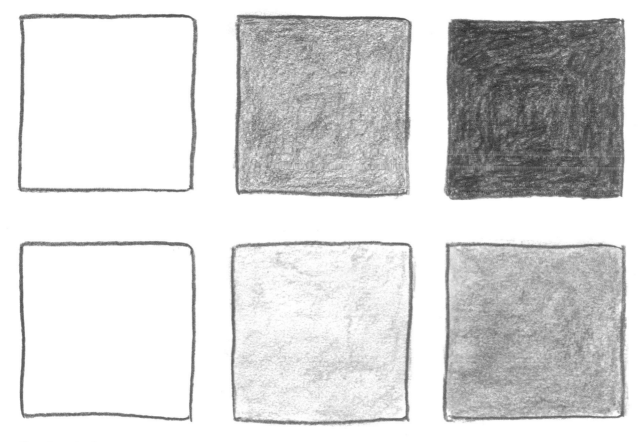

These two sets of squares demonstrate that establishing a middle tone is a relational judgment according to context. The two sets of tonal extremes are different—so too, then, is the middle tone for each set.

Two drawings of the same subject

For this project, you will do two or more drawings from the same still life setup. For the first drawing, the light will be overall and even. Each separate object or area will be visually accessible as a discrete item, each with a particular dark, light, or middle tone of its own. Because there is a one-to-one relationship between the subjects of the drawing and the light order, you will approach the first drawing through local examination of the separate parts. The evenly distributed light emphasizes the subjects in a local way. This first drawing will be equivalent to our "Renaissance" example.

For the second drawing, you will use the same exact still life setup. However, this time, instead of an overall, even distribution of light, you will turn off all the lights and illuminate the setup with only one light source, a spotlight. In this case the subject (identifiable things) and the light order are entirely separate. In effect, with this second version of the still life, you will have two separate drawing problems in the same drawing: the subject as object and the subject as light order: this is the "baroque" challenge. For example, the top half of one of the objects in your still life could be in the light field while the bottom half is in the dark or middle-tone field. Having the light order separate from the objects vastly increases the complexity of the drawing. You will learn to see and draw the abstract shapes, created by the light, as separate from the object(s).

With even light, the D-L-M order in this simple setup is easy to locate according to the objects. The black on the sneaker is dark. The trim, laces, and interior are light, and the cloth and bottom of the sneaker are in the middle.

Try this!
THE FIRST DRAWING: AN EVEN DISTRIBUTION OF LIGHT

Set up a simple still life consisting of a background and a few simple objects. If you like, make it easier and use only one object. (Consider using your lamp on the table with the lamp turned off.) The background could be draped fabric, and the object(s) simple shapes such as a soup can, a cup, or a jug. Choose objects that, when viewed in even light, have clearly different tones. In other words, one object could be dark, another light, and the third a middle tone between the two. Textural differences from object to object can enhance this quality. For example, use a simple single object shape such as a cup as *light*; use a piece of drapery behind the cup as the *middle tone*; and another piece of cloth on the table as the *dark*. The point here is to make local analysis very easy. The lighting should be general, incidental lighting.

For this drawing use charcoal, pencil and your 18 x 24 in. (45 x 60 cm) paper.

Begin with some very loose outlines to give yourself an indication of the general size, location, and character of the separate parts. Think of the background cloth and the tablecloth as objects, to aid in dividing the composition.

Identify which of your shapes will be dark, light, and middle tone. Try to create an equivalent sense of the gradations of value from object to object. In other words, you will be responding with an object-directed orientation.

Once you have the overall shapes in place, complete the drawing with as much detail, using outlines and/or marks, as you wish. As long as you maintain a clear D-L-M, each object will have its own identifiable integrity.

Hang your drawing on the wall. There should be a fairly clear and accessible one-to-one relationship between the objects in the still life and the shapes you have drawn to represent them. The overall even lighting of the still life has made it possible to see the particular visual qualities of each individual object.

First, outline the subject. Maintain line constancy.

Establish your darks first. This way you will know how to judge your middle tone.

With a dramatic light source, the D.L.M. is completely different. The shadow shapes are the darks. The front half of the sneaker and shapes around the shadow are light (bright) and everything else is in the middle.

You will be drawing from the very same still life setup, but the difference now will be in the light used to see the still life. For this drawing, you will need to make the room completely dark. Use a single light source to light your still life. Consider using a pin light or a flashlight taped in position or mounted in some way. If you happen to have a light stand for photo purposes, then all the better. Position the light close to the still life in order to create a dramatic lighting effect. I suggest you place it to the right or left side, aimed from above. The point is to make the shadows as stark as possible.

Suitable drawing materials for this exercise are vine charcoal, regular pencil, charcoal pencil, compressed charcoal, and two colored pencils (red and green). You will also need a piece of 18 x 24 in. (45 x 60 cm) drawing paper.

First, look at the still life. All of the objects are the same and in the same location as before. Only the lighting has been changed. In the first still life, the objects and their visual identity (dark, light, or middle tone) were one and the same. With this new light order, the objects and the visual structure of what you are seeing are completely different. At first, it may feel confusing. You may struggle to differentiate between the objects as subject matter and the light order as visual structure. In fact, they are separate.

Now, just as you did when exercising your peripheral vision, find a particular spot on or near the still life. As before, use a tack or piece of tape placed somewhere in "the field." Focus your eyes on that spot and look at the still life with your peripheral vision. Let the phenomenon of light and dark come to you, to your eyes. While maintaining your overall gaze, try to identify the brightest areas and the darkest areas. What are their shapes? Hint: remember, the brightest and darkest shapes are usually closest to the source of the light.

Outline the subject the same as in the first drawing. Next, outline the brightest shapes in red pencil. Then outline the darkest shapes (usually the shadows) with your green pencil.

With your charcoal make all areas, *except the brightest areas,* a middle tone.

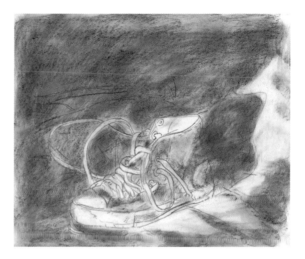

Begin as you did for the first drawing. With your pencil, draw a general outline of the objects to indicate their location, size, and character.

Now, with a red pencil, try to draw an outline around the brightest areas on the field. You will be outlining abstract shapes, which will cross over the shapes of the objects. For example, in some areas, the dark cloth will actually be "bright." As you outline the brightest shapes, you will be simultaneously drawing some of the darkest shapes. They usually share the same edge.

Next try to identify the darkest shapes—the shadows—and outline them with the green pencil. (You will probably be drawing some of those green lines right over some of the red lines.) Using the colored pencils in this way helps you to see the darks and lights as you physically try to form shapes that do not relate to the objects that are in front of you.

After you have located the brightest and darkest shapes with red and green outlines, use your charcoal to make all areas other than the bright areas (the ones outlined in red) a middle tone—yes, including the ones outlined in green. (You may have to establish a few completely black areas in order to know how to make that middle-tone judgment.) As you do this, look for overlap opportunities and try to define them. This may be difficult, as the shapes are going to be completely abstract and, quite often, not connected to the objects. Nevertheless, there will be very hard-edged and dramatic overlaps.

Once you have established everything but the brightest areas as middle tone, use your darkest black to make the shapes outlined in green as dark as you can. (You may want to use your compressed charcoal or charcoal pencils for this.) Be physical and use a lot of pressure. You want to be as dramatic as possible.

Seek out and particularize overlaps. Define your shapes Mark vigorously in the dark, light, and middle tone fields in an effort to enhance details.

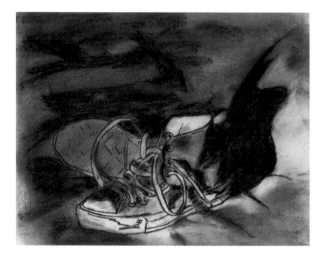

Now complete the drawing with as much detail as you can. If necessary, use your charcoal pencils and/or compressed charcoal and mark the objects again to recall their "object-ness" with detail. See how dynamic and dramatic you can make the drawing.

Hang the drawing on the wall and, without turning the lights on, see if you have been able to achieve an equivalent light order with your drawing. (The drawing as a drawing may seem crude, but if it has an equivalent light order, you should be happy.) It might help to locate a spot on your drawing equal to the one you used as a "resting point" in the still life. Similar to looking at the still life, let the drawing "come to you."

Reminders and suggestions

The success of your drawing will depend on whether or not you were able to:

- represent the light order accurately;

- make the drawing as dramatic as the still life setup;

- use enough contrast;

- define your shapes as clearly as the ones coming from the still life;

- see and draw the abstract shapes caused by the light order;

- define overlaps;

- make the objects in your drawing look and feel similar to the actual ones in the still life.

If you feel the need, go back into the drawing and sharpen it up with more vigorous blacks and sharper edges. If your light order isn't clear you can make it more obvious by using your hands to rub everything that isn't light. You can also use your eraser to recall bright areas. Work the drawing! This will probably be the first time you have done a drawing that is predominantly black (dark).

If you have difficulty untangling the difference between the object-oriented version and the "light-ordered" version, it can be very helpful to take a photograph of the two setups. With this, you could literally trace the light order in an effort to train yourself to see the light (and dark) areas.

Using wet materials

The baroque light-order exercise is a good place to begin working with wet materials. Unlike pencil and charcoal, which give us a sense of greater control, ink or acrylic paints can seem to have a mind of their own—but this is an advantage. There is an increased number of physical qualities at your disposal: a range of stains, drips, scratches, and so on. Though the increased variety may add to a feeling of a lack of control, it also encourages you to give in to the materials and reinforces the idea that drawing is based on finding ways to create equivalencies, on paper, of what you see in front of you.

You may have noticed, when drawing from the "light-ordered" still life, that marking became more critical. For example, when the light order was "local" (an even distribution), defining an object in the still life was relatively easy. You could do it with lines, marks, values, and textural differences. However, when the same still life was changed to a specific "light order," then defining the objects became more difficult. That same object could be half in the dark field and half in the light field, which would diminish the use of value and textural differences as a means to define the objects. You could rely only on lines or marks to define the object. Thus drawing the object demanded particular attention to marking. Since working with wet materials increases your marking possibilities, this is a good opportunity to continue to expand your mark vocabulary.

What wet media?

There are advantages to both india ink and acrylic paints. India ink has a warm, sensual quality. It has an ancient tradition. Most of the classic ink drawings in this book were done with india ink; for example, those by Rembrandt and Picasso. Ink flows nicely and can be used with both brush and pen.

However, I usually recommend the use of what is called "liquid acrylic," either a mars or ivory black, depending on your preference for a warm or cool quality. Liquid acrylic paints are highly saturated with pigment and can be watered down to a consistency perfect for working on paper. And, because they are pigment-rich, they can be thinned down to make a lot of paint. For this reason, they are a lot less expensive than india ink and so allow you to feel more liberal with them.

In addition, acrylic paints produce a molecular chemical bond. As they dry, they actually strengthen the paper, which means you can use less expensive paper. The disadvantage is that they do not work well with pens, though various quills or bamboo points can be used with them. (For this reason, it is a good idea to keep some india ink handy for drawing with pens.)

Additional materials needed for wet work

In addition to your paints (and ink), you will need the following.

PAPER

If you have been using inexpensive paper such as newsprint or cheap drawing paper, you will now need something stronger. Ask your art supply shop for a paper that can stand up to ink, water-based paints, and charcoal pencils.

CONTAINERS

A plastic bucket that holds at least 1½ quarts (1.4 liters) of water. You need this amount of water to keep your brushes clean, as well as some smaller containers with caps that can take at least 4–6fl. oz. (120–180 ml) so that you can store your mixtures. Bigger is better than smaller.

BRUSHES

Acrylic brushes are designed for acrylic paints but can also be used for india ink. (Brushes normally used for oil paints can also be used; they just have a different feel to them.) The sizes can range from a "line maker" to ¾–1 in. (2–2.5 cm). Get a few to start with. After you have worked with the medium for a few sessions, you will have a better sense of what kind of brushes you prefer. There are a host of things to learn about brushes, but for the moment, experiment with rounds and flats. (I prefer flats, but everybody's different. It may be easier to make a variety of marks with a single flat because of the sharpness of its edges.)

A SMALL SPONGE

This is good for reclaiming an area that has become too wet or too dark by blotting up the excess moisture or color. A sponge is to wet media what an eraser is to dry media.

PENS AND OTHER POINTED MARKING DEVICES

Consider bamboo pens, quill pens, feathers, and even sharpened sticks—anything that can be dunked into the medium.

CHARCOAL PENCILS

These need to be tested. Good ones are hard to find. They should make a rich black mark on the dampened paper without tearing it. They should not break easily. They can be very helpful when trying to define (or redefine) overlaps. Ask your art supply shop to help you find ones that will enable you to work on both wet and dry paper.

COMPRESSED CHARCOAL

This becomes very black when used in the wet. This is good for dramatic, concluding marks, and even some fill-ins and adds a textural possibility to the ink or paint.

The large white plastic bucket is for water. The two smaller containers with lids are for storing mixtures. There is a variety of brushes, a sponge to the left, a stick of compressed charcoal in the middle. The taller container in front of the bucket is liquid acrylic. To the left of it is the shorter india ink bottle. In the foreground is a pen for india ink, a bamboo pen, and three different kinds of charcoal pencil.

Getting ready to work with wet materials

Give yourself a lot of space, ideally a big table, to work on. Arrange the supplies around your piece of paper so they are easily accessible. I recommend putting your paper on a table instead of an easel, because you don't have to worry about drips and it is easier to use a sponge.

Now, mix a portion of your liquid acrylic with water until it is as thin as it can be but remains black (not dark gray). Experiment with the amount of water and mixing necessary. You should test it on your paper. It will often dry lighter than it looks when it is wet. Make a lot of this basic black and store it in one of your closable containers.

Next, mix another batch in an effort to make a general middle tone between the black mixture and the white of the page. Test your middle tone. With your charcoal pencil, draw three squares. Paint the right square completely black/dark. Then apply your middle tone to the middle square. You may have hit it right on the spot. If not, experiment by adding more water if it's too dark, or more black if it's too light. Once you have a basic middle tone, make a lot, and store it in another closable container.

Note how this attempt to establish a middle tone has not been effective—it is too close to the dark tone, and so "closes" with it, leaving the two extreme tones with no unifying balance between them.

This attempt has established a balanced middle tone that sits comfortably between the two extremes.

Look at a variety of things and just respond. Let the textures and patterns inspire your moves. Don't hesitate, just put the marks down and leave them. The idea is to get used to the possibilities. See how many different marks you can make with one brush. Then do the same thing with other tools.

Tack or tape a piece of 18 x 24 in. (45 x 60 cm) paper, at the four corners, to your drawing surface. I encourage you to stand up in the beginning and hold the container of the black mixture in one hand and one of your brushes in the other hand. This means your hands will not be free to touch the paper when you start drawing. It also encourages a free-flowing attitude to the marking process. You don't have to take your eyes off of the paper or the subject to find the liquid when you want to reload the brush. You "know" where the paint is, which makes the process more kinesthetically integrated.

• Now experiment making marks with that brush. Proceed by looking at objects that imply marks to you, such as a folded cloth (with or without a printed pattern), decorative rugs, plants, flowers, Venetian blinds, etc. Almost any object in the room can imply marks. See how much variety you can get from that one brush. Be generous with the liquid. Hint: try to mark with the paint on the brush rather than with the brush itself.

• Continue experimenting with the other brushes, the pens, and other pointed devices.

• See what happens, for example, when you mark with the charcoal pencils and compressed charcoal in a fresh layer of your middle-tone mixture.

• Test your ability to clean up an area with the sponge.

Do a few pages of these practice markings. You will be surprised at how many different qualities you can get from these tools. After you have done this, you should have a good sense of the way wet materials look and feel.

As we have seen, marking on shapes "back here on the page," rather than on an imagined version of the objects "out there," can be very difficult to understand. It may be particularly difficult to work with wet materials from subjects we see as having hard edges. The following three exercises will challenge your ability to convert a variety of shapes and patterns presented by objects "out there" into marks and patterns "back here" on the paper. In these still life drawings, your goal is

- to keep an open, unified field in the beginning;

- to practice inventing marks to define your shapes;

- to apply the principle of marking on the shapes first and the edges second.

WORKING FROM OPEN TO CLOSED USING SINGLE OBJECTS

Collect objects that suggest potential mark usage, such as folded cloth (with or without a printed pattern), decorative rugs, plants, flowers, etc. (You could challenge yourself with a decorative rectilinear shape, say a box wrapped with decorative paper.)

Choose one of the objects and try to see its shape-of-space. If necessary, do some empty-hand rubbing (see page 44) and/or use your viewfinder or "hands frame" (see page 46). Imagine the kind of marks you might use for that particular object.

Begin marking, with one of your "wet" tools, on the shape and not on its edge. Be generous with the material. Let the object suggest the marks. Keep an eye out for future possible overlaps.

When you have enough marks to see an "implied" shape, then mark on its edge if you like. Think "discontinuous" marks. Work from one side of the shape to the other.

Stop when you have enough of the image to satisfy your need for completion. These will tend to be quick drawings, so do a lot of them.

A glass jar with a paintbrush in dirty water.

See how much shape character you can achieve without using lines on the edges. See what happens when you make the outlines "brighter" than the interior marks. To correct this problem, put marks on the interior of the shape that are at least as bright as the outline marks.

A shoulder bag on the floor.

A woven basket.

A bag with sewing materials.

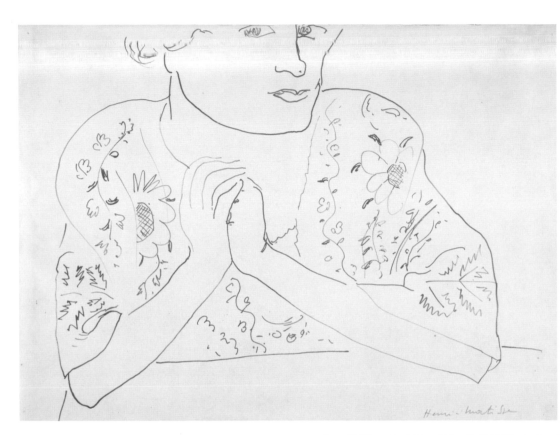

Henri Matisse, *Woman with Folded Hands*, 1918–19. Pen and india ink on white paper. Minneapolis Institute of Arts, John DeLaittre Memorial Collection, gift of funds from Mrs. Horace Ropes, Acc # 25.32.

This drawing by Matisse is a good example of mark variation and integrity. The complex pattern of marks clearly defines the subject's clothing as separate from her body.

As long as the marks are consistently similar for a particular shape, the eye will see them as the same. Marks alone can imply shape by their proximity.

PRACTICE: CHARACTER CONSISTENCY WITH TWO OR MORE OBJECTS

After you have worked with single autonomous objects, try putting together combinations of items, such as two pieces of cloth with similar but different patterns, a collection of branches and leaves, or broken shards of pottery. The challenge here is to practice maintaining character definition with your marks. For example, if you are consistent with the marks you use for a particular piece of cloth, the eye will identify those marks as that same piece of cloth wherever you put them on the page: those marks will be the "language" you use for that item. It doesn't matter so much what the marks are. As long as they are consistent, the eye will read them as part of the same object/shape. (This is a repetition of the exercise with bushes on page 71.)

A SIMPLE STILL LIFE

Set up a still life, perhaps with cloth and a few objects such as a jug and a cup and/or something with a cube shape. Use one plain cloth (to emphasize folds) and one cloth with a pattern (to imply possible marks). Use one for the background and the other to drape under the objects.

With your vine charcoal, make a very general outline of the objects, indicating their size and location.

Using your brush start your still life drawing with a few marks on the separate shapes—the pieces of cloth, the jug, etc. Think of the drapes as objects, too. In the beginning, avoid marking on the edges of shapes. Try to invent marks that are unique to each of those objects. As before, the particular mark is not as important as the consistent use of it for a given object.

Work across the entire field of the drawing, especially in the beginning. Try not to get caught up working on one shape (or area) too much without attending to the others. In other words, keep an equivalent overall pattern of marks on the whole drawing.

Let the process of marking help you find and define the location, size, and shape character of the separate objects.

Once you have a feeling for the whole field, start adding some discontinuous lines/marks on the edges of some of your shapes. As suggested before, seek opposing edges—a few here, a few there. Be intuitive about how much you will want to "close off" the shapes.

Feel free to make use of any tools you have at hand that may seem necessary.

Define the overlaps and stop when the drawing feels right. Keep in mind that this can happen very quickly when using wet materials.

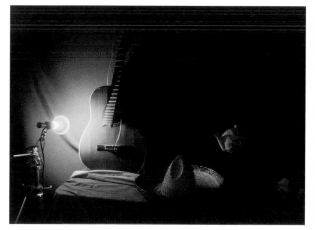
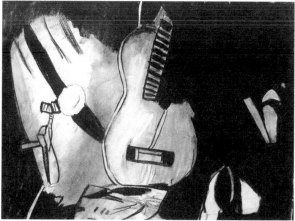

Focus on one spot in this drawing; allow yourself to become aware of the dark field. Now, switch back and forth between the photograph of the setup and the drawing. In spite of a primitive style, this student was able to achieve a dynamic field, capturing the light order and drama of this still life setup.

If you get stuck, look at drawings by other artists. Look at ones that include similar objects/subjects to those you are using. For example, Matisse is particularly good for patterns, but some of Delacroix's drawings from his Arabic period could be helpful, too.

Henri Matisse, *Odalisque Allongée*, 1927. Pen and black ink.

This drawing is another great example of Matisse's ability to maintain mark and line integrity. Note how the lines used for the flesh areas, feet, hands, and face are similar in character and intensity. Note also how mark/line constancy conveys the floral pattern of the dress.

Consider imitating this drawing, or parts of it, using your wet tools. Try, for example, to draw your version of the head. See if you can use marks in a similar fashion to create the veil.

Eugène Delacroix, *First Sketch for Greece Expiring on the Ruins of Missolonghi*, undated. Pencil and brown wash. Sotheby's, London. (photo: Sotheby's/akg-images).

Try imitating the combination of brushwork and pencil of this study. Note the details on the front figure, the bracelet on the arm, the eyes and mouth, the hands, the hair, and the hairpiece.

Try this!
RETURN TO THE BAROQUE EXERCISE

Now you should be ready to use this new arsenal of materials and marks for another version of your baroque still life setup. You will find that drawing the same subject a number of times can be rewarding. Each time you revisit the subject, you will discover new possibilities. As you become more familiar with the shapes, it becomes easier to think and act three or four steps ahead. (By the way, as before, if you find it easier to work from a photo of the still life, then do so.)

With your charcoal, make a general outline of the D-L-M areas and perhaps a few general indications of the location of other important shapes and objects. (These lines are just general location guides. They are not meant to be defining outlines for possible hard-edged fill-ins. Resist the urge to be too accurate or too detailed, and don't let yourself go too far with the charcoal. You are not doing a charcoal drawing.)

Take your container of middle-tone gray in one hand and your brush in the other. Lay in your premixed middle tone in the general area you determine to be the middle-tone area(s) of the drawing. Be generous and exploit the liquidity of the material. Use a brush with plain water if you want to blur the edges a bit. You can also manipulate them with your wet sponge. If there is too much water, you can sponge it up just as you would a spill on the table. (A fat brush can also be used as a sponge. Just sop up the extra liquid and wring it out over your water bucket.)

Use a smaller brush with your black mixture to make some marks here and there. Experiment with the brush. Don't expect it to do what a pencil can do. If, toward the end, you find you need to be more specific than you can with the brush, use the charcoal pencil or the compressed charcoal.

Finally, if necessary, conclude by laying in the black mixture to further define the darks and lights. You can use the black paint or charcoal pencils to specify edges and overlaps.

These two examples of the same cup-and-saucer still life setup show how dramatically different a traditional light order is from a baroque light order.

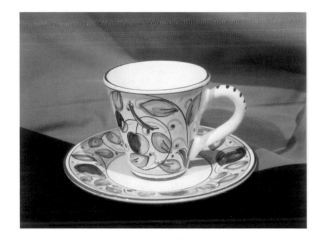

Even light distribution means colors and values can be identified with object separation—the cup and saucer are the lightest shapes, the bottom cloth the darkest, and the background cloth is the middle tone. The objects and the D-L-M structure correlate exactly.

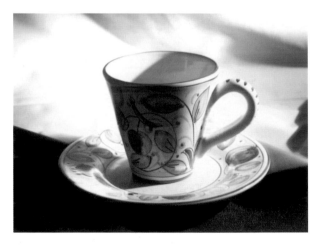

The dramatic light in this baroque version has complicated the relationship between the objects and the D-L-M structure.

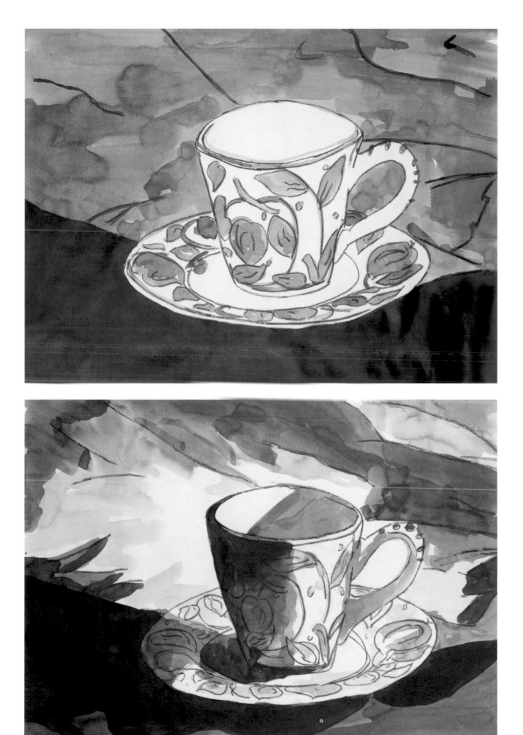

This drawing, with traditional even light, was approached localistically, from object to object.

To effectively deal with baroque light order one must, in a sense, do two drawings: one that defines the objects, and one that defines the abstract D-L-M structure. Note, for example, how the black shadow shape covers the front half of the cup and overlaps onto part of the gray cloth in the background. The brightest areas are on the gray cloth and parts of the cup, inside and out.

Some encouragement

Being accustomed to pencil and charcoal, you may initially experience frustration with this new wet medium. It can take some getting used to, but don't give up. After two or three attempts, you will start to let go and accept the qualities inherent to the brushes and ink or paint. When you get a sense of what these qualities are compared to pencil and charcoal, you will experience a new freedom. There are many advantages to the medium. For example, you can make whole areas of the paper completely black without effort. The material can be very subtle and extremely dramatic. It is cleaner, too, so your hands won't get as dirty. And, of course, it's fun.

Jackson Pollock, *Drawing*, undated. Ink and wash on paper. Burstein Collection (photo: Corbis).

This ink-and-wash drawing is a terrific example of mark invention. The pen and brush are pushed to the limit. Note the clarity of overlap in this drawing, which brings the white shapes within the "cluster" to the foreground. This makes them function as "figure" (subject), which puts the dark shapes in the "ground" (background). It stabilizes the space in the drawing and keeps it from appearing as a void.

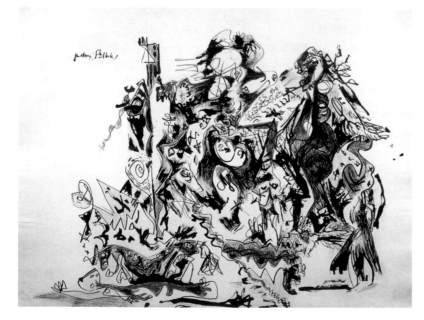

Additional experiments

Here are some other ways you can draw with wet media

- Draw with only one brush. You can use it to paint in big shapes and to make marks. Challenge yourself to see how inventive you can be with that brush, how many different kinds of marks you can make with it, while at the same time maintaining the drawing's integrity.

- Make drawings with pointed tools, such as bamboo pens that you carve yourself. Keep the field open. Then, with a wet brush and water, go over some of the marks again. It loosens up and blurs the marks so you can make readjustments with your black, either with brush or charcoal pencil. You can then unify the field if necessary.

- Do an entire drawing with pen and ink, using only marks. See if you can keep the "ground," or white of the page, feel like a real space and not a void.

- Use a small brush with a very light mixture to mark the paper, then work the drawing again with a combination of small brushwork and charcoal pencil. Try to be as specific as possible with the second working.

- Rework some of your old pencil-and-charcoal drawings (the ones that don't have a lot of charcoal on them) with paint by putting in black or middle-tone gray grounds. Recall the details with brush and/or charcoal pencil. You could try putting black backgrounds in some of your old figure drawings as well.

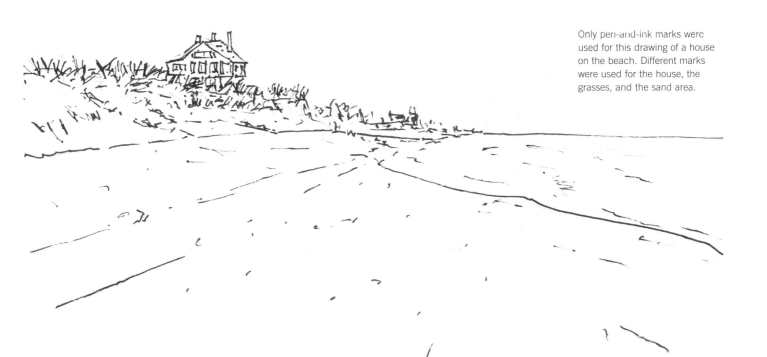

Only pen-and-ink marks were used for this drawing of a house on the beach. Different marks were used for the house, the grasses, and the sand area.

Note how the student was able to organize the reflecting light order from the church to the water by reworking it with brush marks and charcoal pencil.

This apple on a plate served as a quick study of the baroque light order for another larger drawing.

Once you get used to this medium, there is a lot to be gained by working from famous historical paintings. (Of course, you will require projected images or photo reproductions.) In a painting, the three-dimensional shapes have already been translated into their two-dimensional equivalents. In the act of responding to these painted images, you experience the abstraction of the flat shapes, their character, and the clarity of the overlaps.

For this purpose, not all paintings are equal. Some artists are better to use than others. I prefer paintings that have a balance between the illusion created by the shapes and the presence of the paint as an obvious mark creating a shape. Particularly good for this is work by Velàzquez, where a fur drape might have obvious white paint marks that accentuate the fur piece to make it look like ermine, or how Manet can make a glass vase look like glass, but there are many other suitable choices.

Select a painting and look at it with your peripheral vision. Let the painting come to you, to your eyes. See what a possible D-L-M distribution could be.

Begin by using charcoal to outline what you perceive to be the largest shapes, not the shapes as objects but the shapes as shapes, which might constitute your D-L-M distribution. If there are figures, indicate their position as well and add a few marks in charcoal here and there to locate additional details of interest, but not too many.

Proceed as before with your wet medium. Keep it loose and let the fluid flow. Use the brush to lay in large shapes and also to make marks.

Toward the end, particularize your shapes and work up the detail and parts. For example, put eyes and mouth on the figures and marks on the fur, shape the hair, draw the mane on the horse, and so on. You will most likely need to use your charcoal pencil for some of the detailed work, in particular the rearticulation of overlaps.

Strive for high contrast and end by using your blackest black.

Jean-Auguste-Dominique Ingres, *La Comtesse d'Haussonville*, 1845. Oil on canvas. The Frick Collection, New York (photo: Corbis).

This painting has clearly identifiable differences from object area to object area. The object parts correlate directly with the colors, textures, and values.

This student was able to achieve volumetric character in her response to the Comtesse painting. She could have brushed a wash over the mirrored image to put that shape in the middle tone between the dark ground and the light figure.

Édouard Manet, *Bar at the Folies-Bergère,* 1881–82. Oil on canvas. Courtauld Institute Galleries, London (photo: akg-images).

Manet is ideal to work from. This painting is both clear in its representation of the subject and abstract in how it reveals the invented shapes.

It does not matter that this student's version of Manet's painting isn't the same. What matters is how she was able to make use of it in order to experience marking, details, D-L-M structure, and shape character.

Landscape

- Continue to develop your use of peripheral vision.

- Learn how to use the thumbnail sketch to organize your drawing.

- Further develop your use of a dark, light, and middle tone.

- Further develop your use of marks to represent details in your landscape by employing proximity.

There is a traditional notion of the three genres in painting and drawing the figure, the still life, and the landscape (including seascape). Some would describe these genres hierarchically, giving the figure the most importance and landscape the least. This view is based on classical values (the figure traditionally being viewed as the most worthy subject for art), as well as perceived degrees of difficulty and, from our point of view, a hierarchy based on a *customary* perceptual response. Images of the figure mean more to us than images of a still life, so we attach a greater degree of difficulty to drawing them. Because we touch and use the objects in a still life, we perceive this as the next most difficult genre to draw, followed finally by landscape. However, whether we look at a figure, an object, or a landscape, all the shapes we see are visually equal. Learning to see and draw them as flat abstract shapes is the key to drawing by seeing. The landscape, however, is the most abstract of the three because it is a concept and not an object in the same way a figure or still life is an object.

Until now we have confronted the problem of "drawing by seeing" using single objects as our subjects. On a limited basis, we have drawn from combinations of objects as still life. Even when exploring mark invention, we approached nature as a combination of objects, such as trees and bushes. With all of these drawing situations, you have been encouraged to look at the object as a whole shape.

Working from landscape expands our experience of drawing by seeing. If you are still inclined to draw from part to part, then drawing from landscapes will help you overcome this tendency. If you were to try to draw each element of a landscape going from part to part, you would soon become so immersed in the detail of each branch, leaf, or stone that you could drive yourself crazy. To draw a landscape, you need to look at the whole landscape as a single view or as one "object." Because there are so many things in the landscape, you need to learn to see the essential shapes that make up the whole and not just the objects—trees, houses, etc.—as individual parts.

Drawing from projected images

The first time you try to draw from a landscape can be overwhelming. It may be difficult to know where to begin or what to draw and what not to draw. Therefore, if you haven't done so before, consider making your first landscape drawings from photos or projected images before going outside to draw. At least you will have eliminated one major decision: you have decided what you are not going to include. The photo already has established borders that serve as equivalents to the borders of your piece of paper.

There are many advantages to drawing from projected images or photos of landscapes. They allow you more flexibility than you would have if you went outside. You can draw from a large variety of images in a single period and work from your own photograph collection, which adds a personal touch. Another advantage is that you can adjust the images so they are out of focus. When all the edges are blurred, it is easier to see the overall basic shapes, as if you were looking at an earlier stage of the drawing. From time to time, during the process of drawing, you can project your images out of focus and upside down. Then turn your drawing upside down to continue drawing. (If you are drawing from photos you can easily turn them upside down as well.) Suddenly, the abstraction of the imagery will become very obvious. You will know immediately if you have a one-to-one visual equivalency between your drawing and the projected image. Of course, this would be impossible to do outside, unless you are very good at standing on your head.

Other advantages include the possibility of working with others. With everyone drawing from the same projected image, it is possible to compare results and experience each person's unique solution to the same image. Compared to working out of doors, projected images and photographs also remain static and constant. And finally, it is easier to work with multiple materials and the paper won't fly away.

This photograph of a landscape (top) has been blurred (above) in order to make the basic shapes easier to see.

Making a **thumbnail sketch** serves as a small rehearsal for the bigger landscape you are going to draw. It helps you to command the space by encouraging you to reduce all the information presented by the image to its most essential elements. When you make a small practice drawing within an outlined box, just 1 x 2 in. (2.5 x 5 cm) in size, in your sketchbook, you will only have space to make the basic shapes you see, and thus it is impossible to get lost in the details. This is why it is a good idea to make a few thumbnail sketches before you commit to the larger paper. The technique is akin to writing a quick outline before beginning your essay. By doing a small sketch, you will build into your consciousness an overview of what will be required for the larger drawing. Whether you are working from slides and photographs or *en plein air* — in the open air — a quick thumbnail sketch can be extremely helpful.

Begin by selecting a landscape that has a clear and simple composition, i.e., the sky above, the land below, and perhaps a group of trees that overlap the sky and land shapes. Draw a rectangle with your pencil about 1 x 2 in. (2.5 x 5 cm) in size in your sketchbook. Once again, we will be looking for a dark, a light, and a middle tone, so refer back to page 103.

Before you start, look at the landscape and ask yourself: if the composition has three basic shapes, what would they be? Hint: they usually divide between "categories," for example, sky, land, and trees; bodies of water; or top, middle, and bottom.

Do a quick, light outline of those three areas with your pencil and then ask: of the three, which is going to function as the dark, which the light, and which the middle tone? Answering this question highlights your possible choices. With the landscape pictured, your answer might be:

Darkest area Possibly the foreground with green trees, bushes, etc.

Lightest area Possibly the sky shape

Middle tone Possibly the land shape in the distance, being overlapped by the foreground area

Remember, there isn't really a D-L-M relationship in nature, only one that you invent for the purpose of drawing. It is contextual.

Just a simple outline of the basic shapes is enough. Don't try to be too specific at this stage, save it for later. If it helps you, initial the areas with a D, L, or M as in this example of the first stage.

A judgment has been made to keep the overlapped distant shape and some of the sky shapes in the middle tone.

The final touch includes as much detail as possible. Overlaps were emphasized. Note how the little house has emerged. Note how the water shape was saved as part of the light field.

Make a very general linear outline of the three. Next decide which of the three basic shapes will function as your dark shape (the foreground with green trees, bushes, etc.) and, with your pencil, make that area dark. Then decide which of the other two shapes will function as your middle-tone shape (the land shape in the distance, being overlapped by the foreground area) and fill that in. That leaves the sky shape as your lightest area. Check to see if your middle tone actually functions as the tone midway between the other two. If it doesn't, adjust the tones accordingly—remember, what makes the tone a middle-tone depends on the darkness of the dark shape. For example, you could adjust the sketch by either darkening the middle-tone shape area or putting a light layer over the lightest shape area.

Once you have established a D-L-M construction with the three basic shapes, see how much other detail you can include without losing that relationship. Make marks on the trees, bushes, and buildings, if there are any. You will be impressed at the amount of detail possible in such a small space. Don't be afraid to be vigorous.

You have just completed your first landscape! Making the smallest drawing of the biggest subject is a great idea. It makes you more aware of how abstract the practice of drawing is and amplifies the importance of seeing the most essential shapes. The act of drawing is an act of invention. You are inventing visual relationships, with marks and shapes. This becomes patently clear when you confront the amount of visual data in a landscape and try to make sense of it in a very small space.

As stated earlier, the idea of a middle tone does not exist in nature. It is part of the tonal relationship you create on the page. When looking at a landscape with customary perception, you can see that "this area is darker than that area" or "this house is white and the sea is dark." But when drawing those differences, one must determine what that particular relationship will be on the page. There are infinite possibilities. As long as you maintain an equivalent relationship, the particular choices as to which shape is dark, which light, and which middle tone doesn't matter—the drawings will still look and feel right.

There is a fun way to test this idea. Prepare three thumbnail sketches of the same landscape. Draw your rectangular outlines and then, within them, outline the three basic areas. At this point each sketch will look essentially the same.

Now complete the first one as you see the landscape. Let's say you make the foreground shape and tree areas dark, parts of the sky and water light, and the mountain areas and other parts of the sky middle tone. Complete the sketch as before, with as much detail as possible.

In the second sketch, change which shapes will function as the middle tone. If the sky area was light and middle in the first one, make it the dark and middle in the second one, and so on. The mark patterns for details can remain essentially the same.

Do a third sketch with yet another choice for D-L-M— dark, light, and middle tones.

Each sketch will have been drawn from the same landscape. Even though each one has a different D-L-M construction you will be surprised to find how convincing the little drawings will be. A person looking at any one of them will see them as a good sketch of the scene and not question the choices of D-L-M.

Doing these varied sketches as an exercise will expand your ability to make D-L-M judgments and help you learn to see the abstraction inherent to landscape drawing.

Using peripheral vision to help see the landscape

You have already been exercising your peripheral vision with the baroque exercise. Much of the same approach can be applied to the purpose of drawing from landscapes.

USING A FOCAL POINT

Find a place with a landscape view you like. Pick a particular spot in that landscape to use as the resting place for your eyes. (This is similar in concept to the spot we used for the peripheral-vision exercise in the last chapter.) It should not be an "important" spot subject-wise, in order to prevent you from looking at it too hard. It can be close to you or distant. You can try both ways to see which works best for you. As before, focus your eyes on that spot. While maintaining focus, without letting your eyes wander, try to see the whole landscape. Resist the urge to "look out into the landscape space." You want to feel that the "visual data" of the landscape is coming to your eyes. Now stretch your peripheral vision as much as possible. Try to see everything as flat shapes of dark and light. As you do this, become aware of the most obvious dark and light areas. Sometimes it helps to close one eye and/or to squint.

USING YOUR VIEWFINDER OR YOUR "HANDS FRAME"

Mask off a rectangular shape in an effort to help yourself "see the field" as if it were already flat, already a drawn landscape. This should help you decide how much and what part of the landscape you want to draw. Look with one eye closed. This can help you see the field.

SWITCHING YOUR FOCUS

Switch back and forth from your "resting spot" to an object in the landscape. It is very good to practice this with landscape because the difference between the local view and the peripheral view is much more obvious. That house out there is a red house when viewed locally, but may be a dark house when viewed peripherally.

The rectangular viewfinder "contains" the landscape before you and makes it more manageable to draw.

Questions to ask

- What constitutes the largest shapes?

- What areas suggest the brightest shapes?

- How might I divide the rectangular field into the basic shapes of a dark, a light, and a middle tone?

- What possible overlaps can I take advantage of?

- If I were to divide this field into energy areas, which would be the most intense, the least intense, and which could constitute a middle range of intensity?

- What kinds of mark patterns are suggested from area to area?

Draw the landscape

Early on when we made the cloud first and then drew the line/mark second, it established an essential principle of drawing (and painting, for that matter): namely, that the sequence of work starts with a general diffused image and then moves toward specificity and definition of shapes and details. This is solid painting and drawing practice.

For landscape, the idea of finding three basic shapes to serve as possible D-I-M is another way to break down the visual data without requiring you to commit to specifics. The approach is comparable to our use of the cloud. Even when starting out with a landscape drawing, the initial impulse to create sharp edges is strong, but it should be resisted. In the early phase of the drawing, try to keep your edges diffused, as if slightly out of focus. Remember, it is always easy to sharpen your edges, but once they are defined, it is very difficult to loosen them again should you want to make changes. In general, it is a good idea to keep the drawing "open" as long as possible. Commit by including the detail only when you are ready to commit.

Here are three suggested landscape drawing projects. As always, if you get lost, practice looking (see above) and return to drawing some thumbnail sketches of the scene.

This is a simple image, with the sky above, the land below, and some trees and bushes on the land overlapping the sky at certain points.

Think in terms of two phases:

PHASE 1: soft and diffuse

PHASE 2: sharp, mark-oriented, and defined

For this drawing, consider using a combination of vine charcoal for the first phase and soft pencil and/or charcoal pencil for the second phase. Before you commit to a large piece of paper (18 x 24 in. [45 x 60 cm]), it is always a good idea to do a few thumbnail sketches before committing to a large drawing. It helps transform the external scale of the landscape into basic shapes you can use for the drawing process.

With charcoal divide the page into the three basic shapes for a D-L-M construction. For example, if the tree area is dark and the sky area is light, then everything else will become your middle tone.

Shape, with your charcoal, the areas you have decided will be your dark and middle-tone areas using a middle tone. Next, make the dark areas very dark. Then adjust if necessary. To make adjustments, you can either make a shape darker with your charcoal, or make a shape lighter by rubbing with your hands or using your eraser.

Once you have established the basic distribution of shapes according to D-L-M, start making some marks using pencil, charcoal and/or charcoal pencil. Allow the various elements—trees, houses, etc.—to suggest mark variation. For example, different trees and bushes will suggest different mark possibilities to you. As you experience the differences from tree to tree, invent mark patterns accordingly. Try to be physical and intuitive with your marking. Instead of looking and then marking, just let the marks come to you intuitively.

Try to look at the field as if it is already a bit out of focus. Sometimes you can do that by squinting. This makes it easier to see the basic shapes.

Maintain mark logic according to the type of tree or object, from area to area. Control the intensity and character of the marks. Closer objects can be more intense, farther objects can be less intense.

Look for overlap opportunities and define them. Usually the shapes closest to the viewer will overlap those behind, and so on. Sometimes you may need to use your eraser to help make a "light" shape appear to overlap a dark shape.

Where basic compositional shapes such as the "sky shape" and the "land shape" meet, their common edge should feel similar to what you see when you look at the landscape with peripheral vision. For example, if that edge in the landscape is rough and jagged or smooth and pristine, then your edge should be similar.

You will know that you have finished when the drawing has a sense of completeness to you, and an overall feeling of integrity.

To begin, use just enough marking to indicate areas. Note that the buildings in the scene have been accounted for.

This shows hand-wiping, done to diffuse the marks made to unify the field.

The initial laying-in of middle-tone areas with charcoal has also been wiped to keep the drawing unified.

To complete the final phase, use your charcoal and charcoal pencils and commit to black. Take your time and enjoy the process of letting the marks define overlaps and detail to bring the image into focus. Note how the final stage of this drawing has a clearly established D-L-M tone structure.

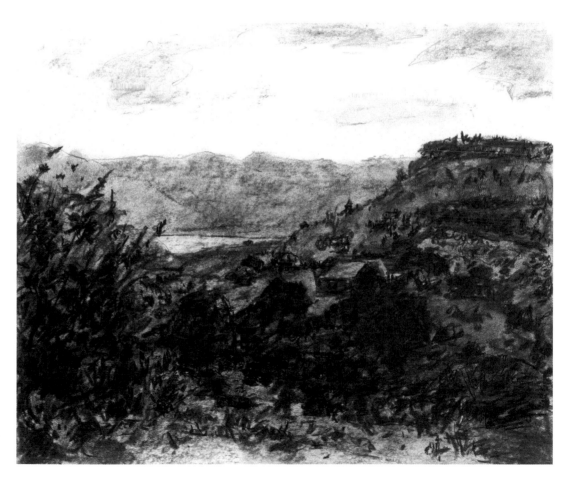

Using wet materials

Landscapes make especially good subjects for working with wet materials. If you find it interesting, consider doing a series of landscape drawings using a combination of india ink (or liquid acrylic), charcoal pencils, pen points, etc. Using ink or liquid acrylic paint to make a dark field is aesthetically healthy, as it keeps your brush physically on the largest shape, the "ground" (background). When you consciously pay attention to the ground, then you are dealing with the "figure" (subject) aspect of the drawing at a more intuitive level.

Working with a dark field is also a very good place to practice mark variation and how it affects brightness contrast. The abstraction of a dark ground makes it easier to see if you are developing an equivalent light order on the page. This is because it is easier to locate a light spot in a dark field than a dark spot in a light field. For example, it is easier to see a distant star in the dark sky than it is to spot an airplane in the daylight.

Finally, working with ink or paint is fun, because you can cover a large area with a middle tone or black quickly.

The range of depth and textures in this seascape offers plenty of opportunity to experiment with inventive marks.

Try this!
LANDSCAPE WITH A BODY OF WATER

This tests your ability to see abstract shapes. Choose a view looking down a beach. The challenge will be to see that view as flat. Try to include some sea grass or other foliage, and possibly some rocks, too. The variety between the water area and the land area will challenge your inventiveness.

Practice your "peripheral vision" techniques by locating a spot on which to focus so your eye doesn't keep wandering.

Proceed, as in the last drawing, by making a general outline separating the dark, light, and middle tone areas with charcoal.

Lay in your middle tone with a medium to large brush.

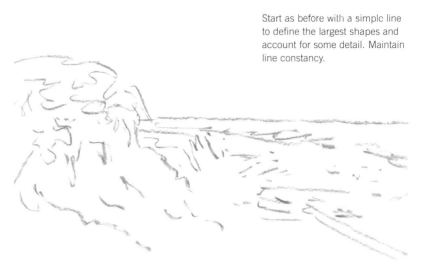

Start as before with a simple line to define the largest shapes and account for some detail. Maintain line constancy.

Brush in a middle-tone wash in the areas you decide will function as a middle tone.

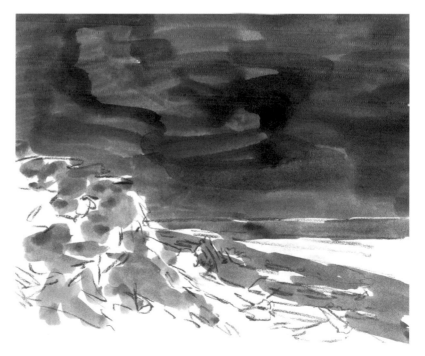

These two drawings from the same site represent different possible conclusions. To do several drawings on the same site from the same point of view is a good habit. It reinforces the difference between drawing and the subject. Each drawing will be different and reflect the unique quality of each moment. See Cézanne's quote on page 58.

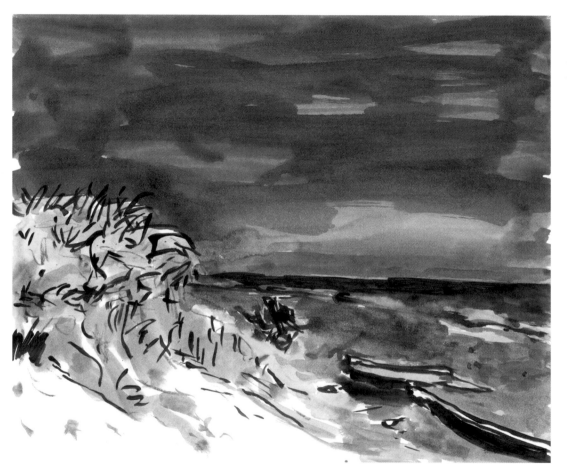

This version of the site has emphasized the left foreground area as the brightest with the addition of brush strokes for sea grasses. This drawing could have been worked further if so desired.

Next, use a small brush with dark mixture to mark the field. Pay particular attention to mark differentiation, i.e., the difference between the marks you use for the sea, plant life, stones, and sand.

Exaggerate size and brightness differences with your mark patterns and clusters. For example, make your marks for the grasses and rocks that are closer to you, the viewer, bigger and more intense (brighter).

Look for and define possible overlaps. Pay particular attention to overlap possibilities with the grasses and other plant forms.

Finally, use any tools you think will help to bring the drawing to a conclusion.

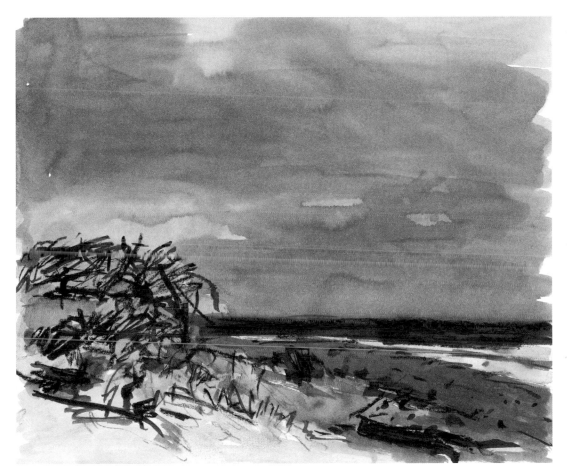

The use of charcoal pencil gives this drawing of the same site quite a different feeling. Notice how the lightest area in this drawing is that little strip of white representing a small wave.

If you squint at this park scene, you will see that dark and light patterns can imply possible energy relationships. An overall dark pattern spreads across the upper-left three-quarters of the field, while the lower-left area has the largest light shape. That means the upper-left area could be seen as a possible area of medium ("middle") energy.

This is a good example of how a thumbnail sketch is able to capture, with marks alone, the basic overall energy pattern of the scene. The student was able to make effective overlaps of the primary tree shapes, the one on the right and the smaller one on the left. This is why the very bright white shape in the back functions as "ground" and not just a void.

Learning to use your peripheral vision with a landscape makes sense because looking at a "vista" requires you to expand your vision. Public parks are also outdoors, but unlike traditional landscapes, they can include buildings, lots of people, a wide variety of trees, bushes, railings, fences, gates, fountains, and so on. At first, you may feel overwhelmed by such a variety of "things" in these environments. It is not as easy to use your peripheral vision. And, unlike a more distant landscape scene, an intimate "urbanscape" may not present easily accessible D-L-M structures such as the sky above, the land below, and trees or mountains in the middle.

Yet parks are great places for drawing precisely because of these challenges. Sit down on a park bench and find a focal point to stabilize your eye movements. Resist the urge to look "out there," from object to object or part to part. Relax and let the shapes come to you, into your eyes. Everywhere you look, exciting shape and mark possibilities will present themselves.

It will help to think of these complex shape patterns as "areas of energy." Without letting your eyes wander, try to identify energy differences; for example, "this area to my right has a lot of visual energy compared to that area to my left." Then see if you can find an area that has a middle amount of energy between the two. This is similar to inventing D-L-M relationships, but instead of tonal differences, you are recognizing energy differences.

You can also use your "hands frame" or viewfinder to study the possibilities. When you crop down, you will see which areas inspire you the most. As before, try a few thumbnail sketches to transform what you are seeing as "things" into marks and shapes. Allow the process to teach you how to prioritize your choices.

Drawing is a way to teach yourself what you are seeing. You are *seeing by drawing.*

This is a good example of how to begin with general outlines and marks to locate the basic subject shapes.

With this sketch, the student was able to capture the essence of the scene by allowing the shadow patterns and leaf patterns to influence her marking process. The shapes of white emerge as light coming through the leaves. Note how she used charcoal pencil to give the drawing more particularity and texture.

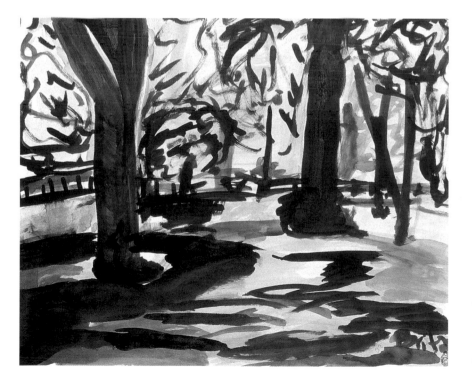

Though this drawing is primitive in style, the student was able to be inventive with the brush, using multidirectional marks to achieve quite complex shape definition.

Select a varied landscape or seascape. If you choose a landscape, include some buildings so that you will have some straight lines and marks; if a seascape, choose one with some boats, for the same reason. Include a variety of plant life. Having these variations will give you plenty of choice for mark-making.

Start with a few thumbnail sketches, but this time see if you can create a D-L-M order solely with mark patterns. Remember from our past mark research that, because of the proximity of the marks to each other, the patterns they make will combine to imply the shapes. In making these patterns you will control the summative visual impact of each primary shape. For example, the dark shape may have the most visual impact, the light shape the least visual impact, and the middle-tone shape will have a visual impact that resides between the other two.

Start by visualizing the essential D-L-M structure. If you need to, do an empty-hand drawing to help locate those shapes. As you mark, try to construct a varied pattern of marks right from the beginning. Put a few marks here, a few there, a little something for everything. Later, those small touches will act as notes and reminders and pay off by providing support as you complete the drawing. Try to avoid completing one area before going to the next. Instead, pay attention to the whole drawing and, as best you can, bring the drawing toward a conclusion by adding the detail across the whole drawing at the same time.

As you look at the landscape (with your peripheral vision, of course), try to be sensitive to the cumulative visual impact coming from the different basic shape areas, and mark accordingly with more energy here, less energy there, etc.

Do not depend on filling in or shading, just rely on the marks you invent as you respond.

At any point in the drawing process, you should be able to stop and have a sense of unity to the drawing. Of course, you can stop at any moment if you like the results you have achieved at that point. Be prepared to have these "mark only" drawings happen very fast. I think that some of Rembrandt's small sketches took as little as a minute or two to complete (see page 94).

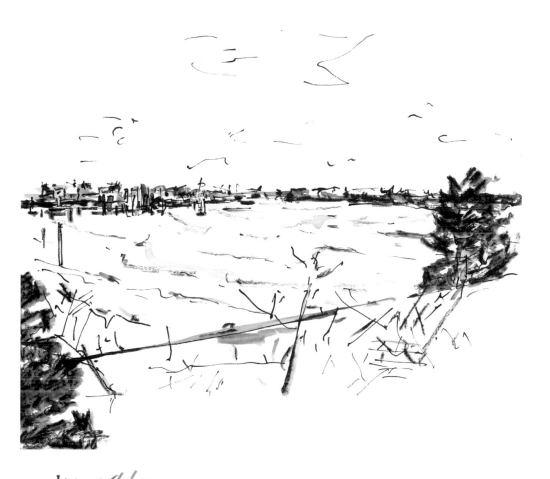

The mark variation in this drawing from the pier and buildings across the bay to the birds and sky gives a sense of the blustery day.

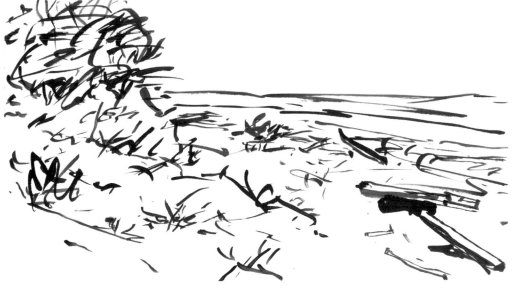

This is yet another drawing from the same sitting as the drawings on pages 137–139. This one is done exclusively with brush marks, giving a different feeling from the same day and the same site.

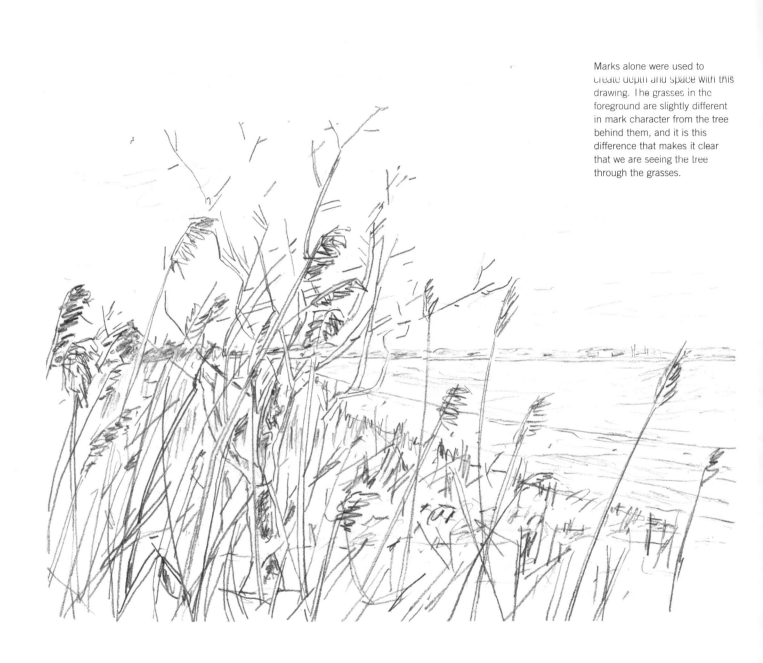

Marks alone were used to create depth and space with this drawing. The grasses in the foreground are slightly different in mark character from the tree behind them, and it is this difference that makes it clear that we are seeing the tree through the grasses.

The grid self-portrait

- Use a grid to look objectively in two dimensions rather than three, reinforcing your progression from customary to aesthetic perception.

- Further refine your use of marks.

- Further refine your use of lights and darks to create depth.

I have come to think of this self-portrait project as "the icing on the cake," as so many of my students get pleasure and satisfaction from it. Over the years I have found myself referring to it as the "Chuck Close exercise," because I identify him as the primary artist from my generation to utilize the grid as a tool to abstract the subjects of his paintings.

My first encounter with his work was in 1968–69. I had been invited to his studio, which at the time was a few doors down from mine on Greene Street in New York. I have a very distinct memory of that visit, coming into the space and seeing his first self-portrait. There, on the wall, was a huge black-and-white portrait of Chuck's face with a smoking cigarette dangling from his mouth. My initial response was, "Wow, that is the biggest photograph I have ever seen." My second response was, "No, it couldn't be a photograph. It's too sharp."

Of course, it was a painting. Chuck proceeded to tell me how he made the painting with a combination of airbrush and razor blades and proudly described how the whole piece was completed with less than a tablespoon of paint. Though a number of artists identified as "photo-realists" emerged in the early 1970s as part of a proto-Pop Art impulse, I have always considered Chuck Close's work to be the definitive synthesis of photography and painting.

Chuck Close, *Big Self-Portrait,* 1967–68. Acrylic on canvas. Collection Walker Art Center, Minneapolis; Art Center Acquisition Fund, 1969 © Chuck Close, courtesy PaceWildenstein.

This work measures 107½ x 83½ x 2 in. (273 x 212 x 5 cm). It is so realistic that, when reproduced at such a small scale, it is almost impossible to see it as a painting rather than a photograph.

The grid

A **grid** is like a map. Placing a horizontal and vertical grid over the complex, organic reality of nature makes it possible for us to locate where we are and communicate that location to others. The grid is a system that objectifies our perceptions. For centuries, artists have used the grid as a tool to aid in their seeing of three-dimensional images as flat. They used them to transfer drawn images to the canvas, to enlarge their drawn images, and so on.

With this exercise, you will experience a means of making images that are in proportion and that have a sense of three-dimensional solidity and depth. Some people appreciate the logic and order of this technique and others find they don't have that kind of patience. If you find you are the latter, your understanding of two-dimensional space will have benefited even if you only make one drawing with this method.

Before beginning this project, you should:

• have mastered the ability to control the intensity of the line.

• understand the difference between the subject as object and the subject as light order. (This project will further your comprehension of baroque light order.)

• be able to handle wet materials.

• be able to see and define effective overlaps.

Taking the photograph

Set up your camera on a tripod and use a timer to take a self-portrait (or have a friend take the picture). Ideally, you will want to exaggerate a light source. Consider sitting next to a window with sunlight shining through, or use a light source similar to the one you used for the baroque exercise.

Take several pictures and pick out one of your favorites. Make a print 8½ x 11 in. (22 x 28 cm) in size. Next draw or print a grid over the photo (the squares should be approximately 1½ x 1½ in. [4 x 4 cm]). The size of the grid can vary according to the size of the paper you use and how much you will want to enlarge the image. (Most people today seem to have mobile phones that can take pictures. Having a digital camera, a computer, and a printer makes this project a lot easier.)

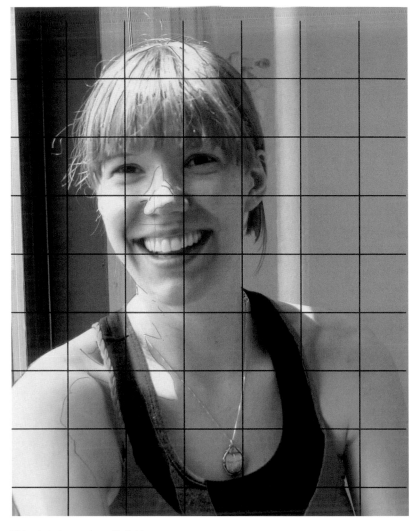

This photo has a dramatic light order. It helps. Notice the white areas on the hair, face, and shoulders.

Preparing the grid

With the above grid, the paper should be 18 x 24 in. (45 x 60 cm). Other sizes can be used, of course, but will require adjustments in the size of the grid you use on the photograph and/or the grid you draw on your paper. The size of the grid determines the degree to which the drawing increases in scale from the photograph. It can vary. You may need to experiment with this a bit, but it is best to err on the side of making the grid too big rather than too small.

Draw a line down the middle of the vertical axis and another line across the middle of the horizontal axis of the paper. The purpose of beginning in the center rather than the edge is to allow for variations in the size of paper. Plotting from the center keeps the logic of the grid consistent.

At the crossing point, make two pencil marks, one 1¼ in. (3.2 cm) to the right and one 1¼ in. (3.2 cm) to the left on the horizontal line. Repeat along the vertical line.

Continue a series of marks every 2½ in. (6.4 cm) on both lines. Use these marks as guides to draw your grid pattern. This will result in squares that are 2½ in. (6.4 cm). This may be too large. If so, make adjustments accordingly.

Draw the grid with medium to light pressure. You want it to be visible enough to see, but not so dark that you won't be able to erase it.

Starting the drawing

The general sequence for this drawing is similar to the one used for the baroque exercise, the difference being the use of a grid to help plot the drawing of the shapes.

Suitable materials to use are regular pencil, colored pencils (red and green), charcoal pencil, and wet media such as india ink or black liquid acrylic.

▌THE FIRST STAGE

Locate squares on your paper that are equivalent to those on the photograph and, using your pencil, start outlining. Concentrate on the edge of the shape of your face. Only draw from one point on a square to another point on that same square.

It is important to maintain line constancy. Continue to proceed from square to square until you have completed the outline for your face.

Next do the same for the shape of your hair. Don't try to draw individual hairs!

Once you have the hair and face shapes outlined, you can do the same for your eyes, eyebrows, nose, mouth, ears, etc. At this stage, you are only outlining the shapes of identifiable objects such as "face," "hair," "shirt," etc. Only use outlines and do not fill in.

Look for overlap opportunities! They will be everywhere.

After you have established the face and hair areas, continue with the neck, shirt, jewelry, etc. Outline any defining shapes in the background, such as the cornice of the window, etc., to the extent you want to include them.

Draw shapes all the way to the edge and off the paper.

Remember, your goal with the first stage is to define the subject with outlines. (Very often, at this stage, the drawing will look complete the way it is. You may want to keep it. If so, just erase the grid. If you do decide to do this, it would still benefit you to continue with the exercise, so repeat the process above to the same point and go on to the next stage.)

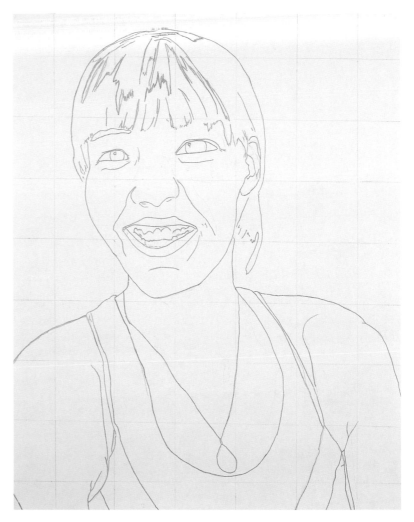

At this point, we are simply trying to locate the edges of primary shapes. Try not to get lost in the details between those edges (lines)—for example, the individual hairs.

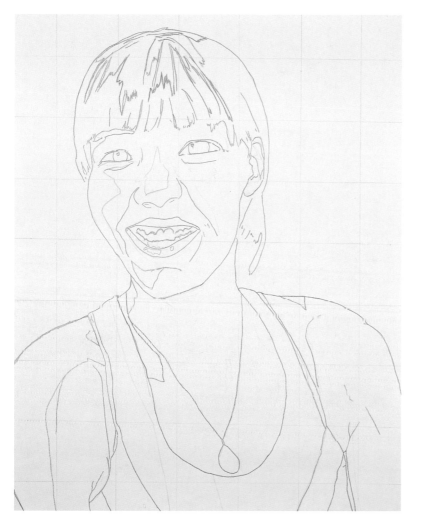

Make it easy on yourself. When in doubt as to whether an area is light or in the middle tone, include it as part of the light field. If necessary, you can always make it darker later.

2 THE SECOND STAGE

With your red pencil, outline, from square to square, the shapes you identify as the brightest ones. In the photograph, it will be possible to see a large variety of gradations from light to dark. Therefore, the best thing to do is decide if a shape is either dark, light, or a middle tone. Some areas could be in the dark or in the middle tone, in the light or the middle tone. Be simple and clear in your decisions. As in the baroque exercise, these shapes will be abstract and hard-edged and will run across objects. It should be a bit easier to find the dark, light, and middle-tone areas in a photograph than when you tried to do this with the baroque still life. The image is already flat.

Use your green pencil and outline the dark areas. As before, the dark areas will sometimes share the same edges as the bright shapes.

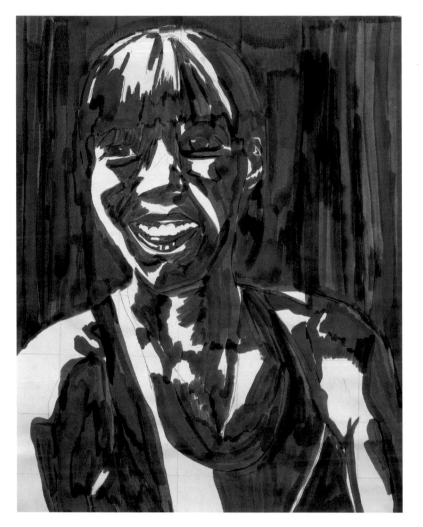

Everything but the areas outlined in red has been painted with a middle-tone mixture. An attempt was made to be multidirectional with the brush strokes.

3 THE THIRD STAGE

First, mix enough of your middle-tone liquid acrylic (or ink) to paint the whole piece of paper.

Next, with a good-sized brush, paint everything except the bright areas (outlined in red) with your middle-tone mixture. It is best to paint in a nondirectional manner. By that I mean avoid using brush strokes that indicate right- or left-handedness. That way your shapes will function more readily as equivalents to the shapes in the photograph. Give in to the natural fluidity of the mixture.

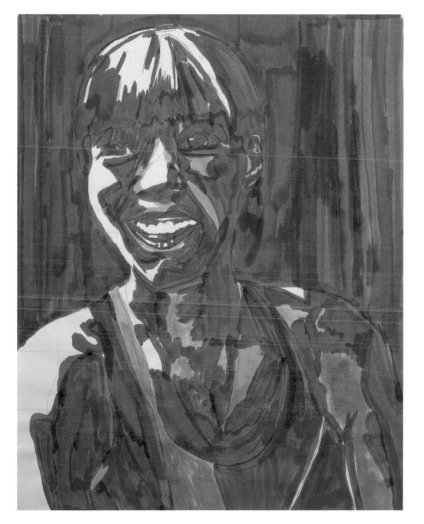

All dark areas, outlined in green, have been painted in with black mixture. Overlaps, edges, and details now need to be defined.

Now, mix a good amount of pure black liquid acrylic (or ink) and paint everything outlined in green (all the dark areas).

At this point, the drawing is almost finished, but usually, the overlaps need to be redefined. The bright areas will often continue to feel like voids behind the dark field when we want them to come forward, to appear to be in front. For example, if the nose or chin happens to fall in the white field, the brush marks at the edge of the black shape (the edge that defines the white shape of the nose or chin) can make the black shape appear to overlap the white shape and thus cancel out the possibility of an effective overlap. Instead, we want the white shape of the nose and chin to overlap the dark shape that forms it. This will make the nose and chin appear to protrude forward.

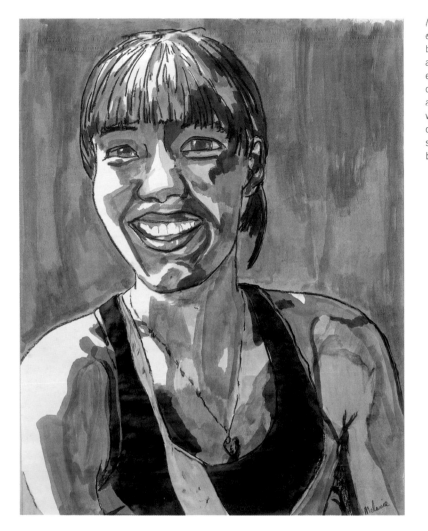

At this stage, details such as hair, eyebrows, necklace, etc., have been worked on and the overlaps and edges redefined. Note, for example, how the ear shape overlaps the hair on the right side and the bangs overlap the face, while the face on the left side overlaps the hair. Almost all shapes are overlapping and also being overlapped at some point.

The solution to this is to use a tool such as a charcoal pencil. With vigorous lines and marks, go back into the drawing and redraw the edges around the nose or the chin, for example. To begin, make discontinuous lines and marks—you need only enough marking to establish the overlaps. Pay attention to where you want a shape to overlap another. Bear in mind that most shapes will overlap at one point and be overlapped elsewhere.

A good example of this will be the relationship between the shape of the hair and the shape of the face. On one side, the face might overlap the hair, and on the other, the hair might overlap the face. Take advantage of this opportunity. You want an effective overlap.

You are finished when the drawing looks dynamic and feels stable.

Bringing it all together

By the time you have worked your way through this book, you should be able to look at a subject, whether it is a single object, the figure, a still life, or a landscape, with an aesthetic perception rather than customary perception.

Simply put, this means that you start off seeing in three dimensions but, in order to draw, and by the time you get to the end of the book, you have learned to see and draw in two dimensions. All the exercises, in different ways, address this basic concept and help you to understand and select from a range of actions appropriate to drawing.

We began with the line-constancy exercise. In order to maintain a consistent intensity in a line, throughout the drawing, you had to pay attention to the whole page, rather than working from part to part. This may have been the first time you made decisions based on the activity of drawing that were independent from the subject "out there." For example, it was with this exercise that you were introduced to the primary two-dimensional depth cues: size, position, brightness, and overlap. Learning to understand and manipulate shapes according to the logic of two-dimensional visual cues added yet another step toward enabling you to take charge of the page rather than to be controlled by the subject/object.

Successful line constancy and clearly defined overlaps make this drawing of a chair convincingly solid, without any shading.

This is a student's first attempt at controlling the brightness difference of two separate shapes. Depth is implied because the brighter (darker) squash appears closer.

With this drawing of squashes, the student has demonstrated more effective control of line constancy and use of the size cue. In this case, depth is implied because the larger squash appears closer.

This drawing makes use of size, brightness, and overlap to give a sense of depth and space.

Together, these two images represent a basic sequence: the cloud is the searching, inventing phase, which sets up the location (on the page) and size (of the shape) for the image-defining line phase. The cloud is most critical. The line-defined image of the chair serves to test the accuracy of the cloud.

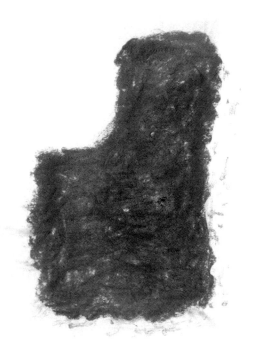

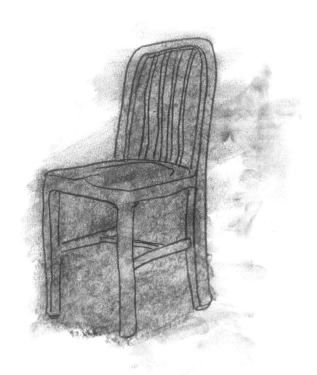

A good example of a cloud, this shape is equivalent to the "shape-of-space" the image of the chair takes up on the retina and on the flat plane of the paper. It was drawn from the inside out with multidirectional marks.

This drawing shows how the cloud was used to provide support for the line drawing of the chair. It has been wiped to reveal the image.

The cloud, perhaps the most difficult exercise to "get," may also be the most useful, because it trains us to see and experience three-dimensional objects/models as two-dimensional shapes. It also contributes to our understanding that, when it comes to drawing, "the whole is greater than the sum of its parts." This is because in order to do the exercise correctly, you must confront the customary tendency to proceed by going from part to part. Using the cloud as a way to make a shape is the polar opposite from the outline. Doing a successful cloud shape may have been the first time you made a shape that simultaneously defined its own edges.

Together, the line and the cloud exercises helped you experience, kinesthetically, the difference between three-dimensional and two-dimensional perception and the difference between drawing from part to part and drawing holistically.

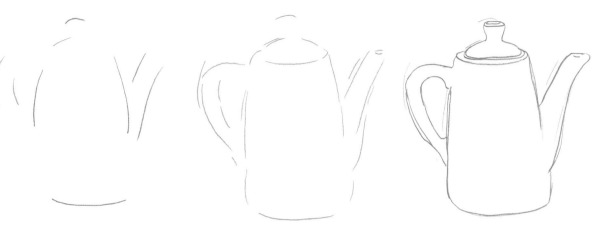

Instead of starting at the top of the pitcher and drawing one continuous line to "capture" it lasso-fashion, this beginning shows an attempt to "find" the shapes by marking opposite edges. This approach is more effective, as it is dealing with the real shapes on the page rather than trying to touch an imagined version of the pitcher in a non-existent "void of space."

The initial image has made it possible to commit further to the shape of the pitcher in this second phase of the drawing.

The concluding lines/marks are relatively accurate. The lines function as edges of shapes that imply volumetric form rather than lines that "float" in the void like spaghetti.

In the chapter on marking, you were introduced to the phenomenon of proximity, an organizing tool that can help you use marks to imply shapes. Because of proximity, you don't have to fill in or outline a shape completely to give it definition and stability. For example, with just a cluster of marks you can "imply" the cloud shape. Implying a shape keeps the drawing open to adjustments for a longer period of time, which, in turn, means more flexibility in the exploration and identity of

the shapes. We also discovered that shapes with implied edges could be just as stable as shapes with completely closed edges. Most important, however, you experienced the difference between marking on an imagined three-dimensional object that exists in an imagined "void of space," versus marking on a shape that exists on the two-dimensional piece of paper. Or, to put it more simply, this is the difference between an external (on the object) response and an internal (on the page) response.

This early stage of a drawing of a fir tree shows how the mark pattern implies the shape of the tree *right from the beginning*. The marks are multidirectional and relatively consistent in character and intensity.

As the drawing progresses, the pattern of marks has become denser and more particular in character.

The marks are now beginning to coalesce to imply branches of needles. The artist could stop here, but has gone on to add more needles to complete the drawing (right).

Throughout the process, the drawing has maintained the overall shape of the fir tree. At each stage there was a sense of wholeness and unity. This sequence exemplifies a process that goes from the general to the specific.

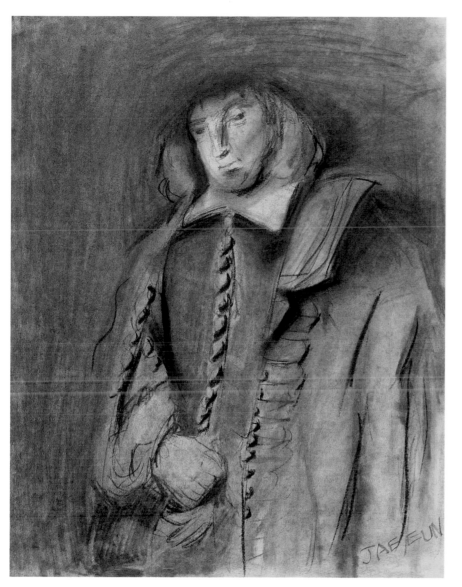

Working from a Rembrandt portrait painting, this student was able to address such details as the decorative elements on the coat, the hand, and the features of the face. The next time she draws something similar, these mark and detail experiences will be available to her. They are now embedded in her kinesthetic memory.

The baroque exercise required us to look at the "whole field." It expanded our understanding and introduced us to the use of peripheral vision. Through very straightforward setups we learned how light order affects the distribution of lights and darks across an object or collection of objects and in our drawings. We also experienced the difference between an object's discrete colours and values when viewed locally and how the colors and values changed when that same object was viewed with peripheral vision. This change, from the objects as the subject of the drawing, to the light and dark order as the subject, required us to use our marking skills much more effectively. And, unlike most of the drawing to this point, we used dark (the ground) as the largest shape and light (the figure or object) as the smallest shape, similar to the Baroque painting tradition. This chapter also introduced the use of wet materials, enabling us to make those dark fields more easily and increasing the drama potential of our drawings.

The chapter on landscape took us one stage further in our exercise and use of peripheral vision. Similar to the Baroque use of light order, the overall view of the landscape becomes the subject. Unlike the still life, a landscape can encompass an infinite amount of objects and details. Therefore, out of necessity, it is the most conceptual and abstract of the genres. With the landscape (or seascape) as subject, it is essential to learn how to prioritize our choices.

One way to avoid becoming overwhelmed by the enormity and detail in the view in front of you is to do a thumbnail sketch. Organizing the overall field (of the landscape) according to dark, light, and middle-tone areas helps us to prioritize choices. Understanding the abstraction of landscape reinforced the importance of expanding your mark vocabulary and mark combinations as visual equivalencies.

This charcoal drawing (below) of a New Mexico landscape (with its thumbnail sketch to the right) has maintained an identifiable clarity between the dark (as shrubs and hills in the background), light (as sky area), and middle tone (as the sandy area around the shrubs).

This student wash-and-charcoal drawing of the same New Mexico landscape has a successful though different D-L-M relationship, reminiscent of the work of the American painter Milton Avery.

These drawings are from the same scene. The first one effectively makes use of marks alone to create a feeling of depth. The marks in the foreground are the most intense and aggressive. The marks in the distance, across the bay, are the lightest, and the marks in the middle-ground areas function as a middle tone between the other two areas.

The second drawing was done with wash, brush, pen, ink, and some charcoal pencil. In this case, the dark is most of the water shape, while the light (bright) area is in the foreground and the distant area across the bay and part of the water area function as the middle tone.

By locating the brightest area of
this beach scene in the splashing
wave area and using varied
marks, this student's first ocean
drawing turned out pretty well.

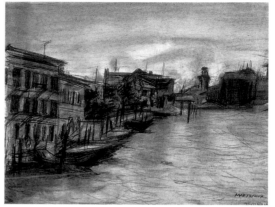

A dramatic view of a pier on San Pietro in Volta presents a fun challenge. This charcoal-and-pencil drawing shows how aggressive and inventive marks were used to respond to the challenge.

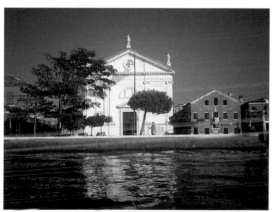

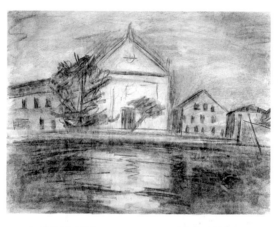

This photo of a church on San Pietro, as seen from the water, suggests a clear D-L-M relationship. The white church is an obvious "light" shape that could be used to key the dark and middle-tone shapes.

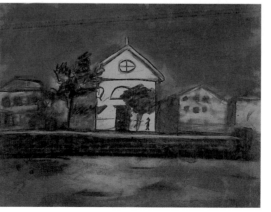

These drawings are good examples of how different the results can be from the same image. In both cases, the church shape functioned as "light" and there was an ability to locate a reflection off the water area, but each student expressed very different feelings in their mark patterns.

Finally, in the grid self-portrait exercise, we made use of a grid system, a technique dating back to the Renaissance. This tool serves as a way to look at the three-dimensional subject with two-dimensional objectivity. (It was particularly challenging to be objective, as the subject was you!) This project encompassed all we have learned, from seeing shapes as flat, to controlling lines and marks, to dark and light order.

But the important lesson here was how the grid showed us the degree of abstraction inherent in a strictly flat view of a visually complex and potent image. We experienced how the shapes and their edges, when viewed in this flattened way, are so very different from when they are viewed with customary perception. In the end, you were able to make a pretty good version of yourself.

You can tell this student started with a middle-tone cloud to help locate this portrait of a girl reading. When she realized her shape was too tall, she was able to make an appropriate adjustment.

This is a very dramatic grid self-portrait. The light order is clear, and the detail and overlaps are well-defined.

Although these self-portraits were done using the same grid system and sequence of layers, each drawing has a unique feeling. Each student had a different touch with the brush and a different way of marking. Most of these students had little or no experience of formal drawing prior to working through this series of exercises.

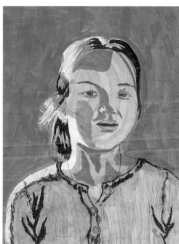

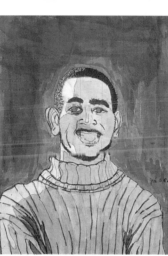

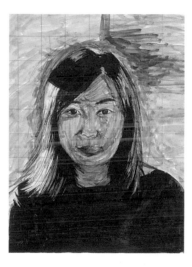

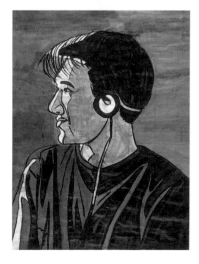

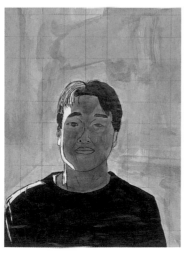

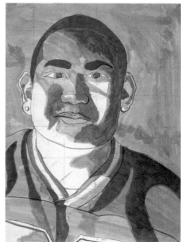

The sequence of exercises in this book is designed to make you conscious of the conflict between customary perception and aesthetic perception. As you draw, you become aware of the body's automatic customary responses. These appear as kinesthetic clichés and account for the unintended distortions that happen in your drawings. Alas, the conflict between customary perception and aesthetic perception will always be there. For example, you will always want to show more than you see, or look from part to part. These responses are built into our very musculature. However, the exercises help to bring the source of these kinesthetic responses to consciousness, which demystifies them. Now, instead of simply responding to them with frustration ("I just can't draw"), you can use them as tools, or signposts, to make in-process adjustments such as repositioning, size changes, defining overlap, and so on. In a sense, the act of drawing itself has become a process by which you teach yourself what you are "seeing." Every time you pick up a piece of charcoal or an ink-loaded brush, the possibility of seeing something new can be acted out on the page. Drawing is no longer a mysterious and frustrating process. Instead it has become a creative and exciting challenge: Drawing by Seeing.

Further information

Glossary

aesthetic perception
how we need to see the world for the purposes of drawing—in terms of two dimensions rather than three.

brightness
one of the four primary depth cues appropriate to drawing. The most intensely drawn shape on the page—and therefore seemingly the brightest—will appear closest to the viewer.

character
the expression given to lines, marks, and shapes to emphasize their uniqueness.

cloud exercise
an imagined flat version of the object/model on the piece of paper that is equivalent to the whole shape of the object. The cloud shape is drawn from the inside out; therefore the shape and its edges are always simultaneously present.

contradictory brightness cues
result from our customary response to drawing when we view a flat piece of paper as an imagined three-dimensional void. We try to reach into the imagined space and therefore use too much pressure in those "deeper" areas, causing them to appear "brighter." Thus, areas that should appear to be closer to us seem further away and areas that should seem farther away appear closer. To correct this, we need to retrain our musculature so that areas that we want to seem nearer to us are "brighter" and those farther away are "lighter."

contradictory depth cues
a common symptom of an imaginary tactile response. This occurs in our work when we push down harder with our pencil in an effort literally to "reach" the deeper areas of the space, and pull back with a lighter touch in the areas closer to us. By attempting to reach into flat space as if it were three-dimensional, we inadvertently create visually contradictory cues for depth perception.

customary perception
how we use our eyes for everyday functioning. It is our normal seeing process and is integrated with all the other senses, plus memory, experience, and knowledge. It has the same three-dimensional meaning and function for everyone. It is in direct conflict with aesthetic perception.

dark, light, and middle tones (D-L-M)
an organizational tool that aids in the drawing of more complex images, such as landscapes. By establishing a middle tone—between areas that are darker and those that are lighter—you can bring visual unity to the plane of the picture.

defining overlap
making one shape appear to be in front of another shape. It is the most convincing of the four depth cues.

depth cues
sometimes referred to as monocular depth cues, they are the four primary depth cues—position, size, brightness, and overlap—that can apply to the flat plane of drawing.

depth perception
our ability to see depth in three-dimensional space, and the illusion of depth in a two-dimensional drawing.

discontinuous line
making a mark here and a mark there to imply an edge. This is done by proceeding back and forth from one edge of the shape to the opposite edge. This trains the eyes to become accustomed to looking for and seeing the shape that defines the edges, rather than making one long continuous lassoing of the shape that is likely to float on the surface of the page. A discontinuous marking approach keeps the drawing "open" longer to allow for the most potential changes.

drawing-oriented

the drawing as the primary focus. Instead of being too dependent on what you are seeing "out there," you are able to pay attention to what is happening "back here" on your piece of paper. This enables you to consider how best to represent the object/model in two dimensions.

empty-hands technique

rubbing the page with the flat of your hands in the shape of the object/model you are about to draw. This reinforces the flatness of the page.

field

the biggest shape you can see with your peripheral vision, be it the landscape, still life, figure, or the whole page of the drawing with all its elements.

figure–ground

the "figure" is the primary focus of the viewer's attention, as opposed to the "ground," which is the "field" or environment in which the figure or "object" of primary attention is situated. The Gestalt figure–ground relationship is not to be confused with that of the "object" and "background" of a painting. Rather, it is a more fluid and dynamic relationship, dependent upon the individual viewer's particular perception at a given moment. Every shape in a drawing can serve either function. The ground should not function as a void, but rather should feel solid and stable, existing in an integrated relationship with the figure. The sign of a successful figure–ground relationship is when the ground feels stable or "present" and not like a void, giving the drawing visual stability.

grid

a tool for objectifying three-dimensional space in order to see it two-dimensionally, it consists of a series of horizontal and vertical lines placed over an image. It breaks the image down to small squares of abstract visual data, which makes it easier to "see" the shapes as two-dimensional abstractions rather than the three-dimensional objects we "know" them to be.

hairy line

this is one of the kinesthetic clichés. It results from a repetitive movement of short strokes. An accumulation of these strokes appears like a mass of "hair" on the edges of shapes. This is a kinaesthetic habit that comes from an unconscious and insecure customary response to a drawing problem. It is a tactile response and not a visual one.

"hands frame"

like the viewfinder, a convenient way to look at the subject as a visual abstraction. It involves holding up your hands with thumbs touching to "frame" the object/model in an effort to see it two-dimensionally.

hierarchical valuing

like part-to-part ordering, this involves working on part of a drawing before moving on to another. Parts are worked on in order of their perceived importance according to customary valuing, be it the order in which they are put together (a still life), the order in which they grow (a tree), or the a value we place on the different parts (the head in figure drawing, for example).

horizontal baseline cue

a position-based depth cue. Objects that are nearer to the horizon look larger.

imaginary tactile response

attempting to draw an object by imagining it placed in a three-dimensional spatial void—represented by the two-dimensional piece of paper in front of us—and then unconsciously trying to "sculpt" the object in that void. Drawing by imagined touching of the object's edges will always result in unintentional distortions.

kinesthetic clichés

these include irregular or hairy lines, overemphasis of points of intersection (which in turn cause contradictory depth cues), and part-to-part ordering. They are a result of physical knowledge embedded in our very musculature. This knowledge is unconscious and is one of the reasons we try to touch the flat piece of paper in

the same way that we would touch the three-dimensional object.

lazy lines
lines meant to define a shape's overlaps, but when they cross over each other, it cancels out the possibility of a defined overlap, resulting in a loss of volumetric character and spatial depth.

light order
how the distribution of light organizes dark, light, or middle-tone shapes on any field view. The light order may align itself with the subject (even overall light) or it may not; a light order can be completely separate from the subject/object.

line constancy
a line without any variation in intensity (darks and lights).

mark patterns
patterns of marks that imply shapes, often informed by the principle of proximity.

object-oriented
a tendency to focus on the object "out there" rather than on the drawing—what is happening "back here" on the paper.

outline
a line drawn to represent the edge of the shape of an object. Correctly drawn outlines will function as edges of perceived shapes and will give volumetric character and stability to those shapes. Outlines that don't function as edges will often seem to float on the page.

overlap
the strongest of the four primary depth cues, it causes one shape to appear in front of the others. It can appear closer to the viewer, even if it happens to be smaller than the others, because it overrides the size cue.

part-to-part ordering
the tendency to complete one part of a drawing before moving on to another part, or moving sequentially from left to right or top to bottom.

peripheral vision
wider vision. In customary perception, we tend to focus on particular points, from object to object, according to customary valuing. Peripheral vision enables you to look at the widest possible field.

points of intersection
places in the drawing where shapes, lines, or edges intersect with each other. Overemphasizing these points often causes contradictory brightness, a kinesthetic cliché.

positioning
the ability to put shapes where you want on the page. It is one of the weakest depth cues, except when used in tandem with the horizontal baseline cue, which means that shapes or objects lowest in your field of vision appear closest.

primary depth cues
the visual devices that give a drawing the illusion of three-dimensional depth. They are positioning (in tandem with the horizontal baseline cue), size, brightness, and overlap.

proximity
a Gestalt concept of visual order. Things, shapes, and marks placed together — in close proximity — are perceived as one unit. The eye mentally fills in the empty spaces between them and gives them meaning as a single entity.

shape-of-space
the flat shape on your retina of any object or field you are paying attention to.

shaping
creating a shape from the inside out, whether it be a solid shape, as in the "cloud," or an open shape drawn with a variety of marks, rather than by outlining.

size
one of the four primary depth cues. The largest shape will appear closer to the viewer.

stable shape
a shape that appears to be solid and looks as if it exists in real space rather than floating in a void.

star pattern
a pattern of marks placed on the paper to imply the shape-of-space of the object you are seeing and responding to.

successful overlaps
these are created when lines meet without crossing over each other, allowing one shape's edge to yield to another.

tentative lines
lines that do not meet, and therefore the shapes cannot overlap.

thumbnail sketch
a small drawing—around 1 x 2 in. (2.5 x 5 cm)—of the object or landscape that you wish to draw. It enables you to organize the image by locating the essential elements, and identify the dark, light, and middle-tone areas. It can function as a "rehearsal" for a larger drawing.

unintentional distortions
distortions in our drawings that occur as a result of trying to draw using customary perception, rather than aesthetic perception.

viewfinder
a rectangular or square piece of card with a rectangular hole cut out of it, which is held up in front of the object/model being drawn to "frame" it. This is a way of objectifying the subject in order to see it in two dimensions.

Picture credits

Laurence King Publishing Ltd. has paid DACS' visual creators for the use of their artistic works. Every effort has been made to contact all copyright holders. The publishers will be glad to make good in future editions any errors or omissions brought to their attention.

Page 30 Pablo Picasso, *Two Nudes on a Beach* © Succession Picasso / DACS, London 2006

Page 32 Henri Matisse, *The Mane of Hair* © Succession H. Matisse / DACS, London 2006

Page 41 (left) Henri Matisse, *Self-portrait* © Succession H. Matisse / DACS, London 2006 (photo: © 2006 Digital image, MoMA, New York/Scala, Florence)

Page 63 (left) Henri Matisse, *Nu Assis, vu de Dos* © Succession H. Matisse / DACS, London 2006

Page 63 (right) Pablo Picasso, *Portrait of Erik Satie* © Succession Picasso / DACS, London 2006

Page 64 Oskar Kokoschka, *Portrait of Adolf Loos* © DACS, London 2006

Page 92 Oskar Kokoschka, *Woman in a Robe* © DACS, London 2006

Page 96 Roy Lichtenstein, *Study for "Tension"* © The Estate of Roy Lichtenstein / DACS, London 2006

Page 102 Georges Braque, *Statue d'Épouvante* © ADAGP, Paris and DACS, London 2006

Page 114 Henri Matisse, *Woman with Folded Hands* © Succession H. Matisse / DACS, London 2006

Page 116 Henri Matisse, *Odalisque Allongée* © Succession H. Matisse / DACS, London 2006 (photo: Sotheby's / akg-images)

Page 120 Jackson Pollock, *Drawing* © ARS, NY and DACS, London 2006

Photography: Richard Sylvarnes, Peter Clark, and Yuji Takahashi
Model: Gina Bonati

The following students have kindly agreed to allow their work to be reproduced in this book:

Allison Bengston
Natasha Blank
Hilary Brown
Michael Cavayero
Jae-Eun Chong
Cortney Cooper
Anna Del Gaizo
Jennifer Fleischer
Rebecca Forgac
Dania Garcia
Julia Goodman
Lee Hagerman
Phillip Herschfeld
Brad Horowitz
Kathryn Howard
Melanie Jelacic
Gautam Kamthan
Douglas Kelley
Ryan Kelley
Steven Lam
Tiffany Leung
Grace Lim
Shelley Lynch-Sparks
Joan Ma
Shahjahan Malik
Patricia Montese
Rebecca Montrose
Jose Monzon
Jane Anne Morton
Daniel Motta Mello
Kasia Munson
Michael Newman
Theresa Nguyen
Thalia Pentelis
Jessica Pinsky
Jenna Rosenberg
Tamar Schiller
Samantha Sherman
Moo Kyung Sohn
Seth Thomases
Jonathan Udelson
Sean J. Yeam
James Yi
Frances Ward
Rebecca Whitehill
Sabrina Whyte
Nelya Zoni

Further reading

Arnheim, Rudolf. *Art and Visual Perception: A Psychology of the Creative Eye*. Berkeley: University of California Press, 1954.

————. *Visual Thinking*. Berkeley: University of California Press, 1969.

Clearwater, Bonnie. *Roy Lichtenstein: Inside/Outside*. North Miami (Florida): Museum of Contemporary Art, 2002.

Deitcher, David. *Unsentimental Education: The Professionalization of the American Artist*. From the catalogue of the exhibition "Hand-Painted Pop: American Art in Transition, 1955–62" at the Museum of Contemporary Art, Los Angeles, 1993.

Edwards, Betty. *Drawing on the Right Side of the Brain*. New York: St. Martin's Press, 1989.

Holm, Michael Juul, Poul Erik Tøjner, and Martin Caiger-Smith (eds.) *Roy Lichtenstein. All About Art*. Humlebæk (Denmark): Louisiana Museum of Modern Art, 2004.

Huxley, Aldous. *The Doors of Perception*. New York: Harper, 1954.

Lobel, Michael. *Image Duplicator: Roy Lichtenstein and the Emergence of Pop Art*. New Haven: Yale University Press, 2002.

Sherman, Hoyt L. *Cézanne and Visual Form: Part Two*. Columbus: The Institute for Research in Vision at the Ohio State University, 1952.

————. *Visual Demonstration Center: A Manual of Operation with Emphasis on the Arts: Part One*. Columbus: The Institute for Research in Vision at the Ohio State University, 1951.

Sherman, Hoyt L., Ross L. Mooney, and Glenn A. Fry. *Drawing by Seeing: A New Development in the Visual Arts through the Training of Perception*. New York: Hinds, Hayden & Eldredge, 1947.

Index